CALLIGRAPHY TODAY

Heather Child

STUDIO VISTA

LONDON

Calligraphy
is the most direct form of all artistic expression

JUST AS EACH MOVEMENT
OF THE DANCER IS ABSOLUTE
SO EVERY GESTURE
OF THE CALLIGRAPHER
IS ESSENTIAL

IT IS NOT THE MEANING OF THE
CHARACTER BUT THE WRITING —
THE MOVEMENT OF EXECUTION
AND THE ACTION ITSELF —
THAT IS IMPORTANT

Heather Child Transcribed from the introduction by Tseng Yu-ho
Ecketo, *Chinese Calligraphy*, 1971

Acknowledgements

I acknowledge with gratitude the help of all who have lent work for the illustrations; the advice given to me by fellow members of the Society of Scribes and Illuminators; and the assistance of Lloyd Reynolds, P. W. Filby, Rick Cusick, Friedrich Poppl and Villu Toots. I am grateful to the Trustees of the Victoria and Albert Museum for permission to reproduce from their collections. I should also like to thank Dorothy Colles for her help and advice in the making of this book.

A Studio Vista book published by
Cassell & Collier Macmillan Publishers Ltd,
35 Red Lion Square, London WC1R 4SG
and at Sydney, Auckland, Toronto, Johannesburg,
an affiliate of
Macmillan Publishing Co., Inc.,
New York.

ISBN 0 289 70736 6

Designed by Brooke Snell
Set in Bembo 12 on 13 pt.
Filmset and printed by BAS Printers Limited, Wallop, Hampshire
Bound by Webb & Sons Ltd

Contents

Choice of Illustrations

In the 1963 edition of *Calligraphy Today* the illustrations were arranged in four main groups to illustrate the principal themes of the text. A small selection of historical hands led to a fuller treatment of the work of the pioneers and early masters of the revival. The modern works showed original manuscripts and panels from calligraphers practising in Britain, Europe and America. A representative section of work designed for reproduction, such as book jackets, certificates, book plates and the like, was rounded off with a selection of exemplars and aids to teaching the craft.

This new edition of *Calligraphy Today* does not supersede the last but should be considered as an adjunct to it. The aim has been to show a logical sequence of development, and some unavoidable repetition occurs in the discussion of the work of the pioneers of the revival and the founder members of the Society of Scribes and Illuminators.

Whereas the earlier edition drew its illustrations from the first half of the century, however, the illustrations to this edition have come almost entirely from the last ten years. The emphasis has been put on showing the spontaneity and freedom characteristic of examples in this period, and the exhilarating variety of some of today's calligraphic artists.

Material from the Victoria and Albert Museum's collections is well represented and has been chosen because the originals are accessible. Calligraphy ideally needs to be seen in the original and, if possible, handled, in order to appreciate the subtleties of craftsmanship and the tactile qualities of the materials.

A choice of works originally designed for reproduction is illustrated, showing the versatility and range of smaller items in which calligraphy can be of special service.

Calligraphic styles and letter forms are used more widely today by stone-carvers, wood and glass-engravers, potters and other craftsmen. Although these categories fall outside the province of this book, a few illustrations are nevertheless included, to give some idea of this lively extension of calligraphic practice.

A Note on Definitions

Descriptive terms for common activities are often used without regard to subtle distinctions of meaning. The terms 'writing' and 'lettering', for instance, are used so loosely that there is often confusion between these two processes. It may be helpful to provide modified definitions from the Shorter Oxford English Dictionary:

WRITE, *v*. To score, outline, or draw the figure of. To form letters, symbols, words by carving, engraving or incision. To form or delineate . . . on paper or the like with pen, pencil, brush etc. To inscribe letters in or upon a hard or plastic surface. To form by painting or the like; to paint (a sign, etc.). To print by means of a typewriter.

WRITING, *vbl. sb*. The action of one who writes in various senses. The art and practice of penmanship or handwriting. Style, form or method of fashioning letters or other conventional signs (especially in handwriting or penmanship); the 'hand' or handwriting of a particular person.

LETTERING, *vbl. sb*. Letter writing, putting letters upon anything by inscribing, marking, painting, gilding, printing, stamping etc.

Edward M. Catich, in the descriptive book to his portfolio *Reed, Pen and Brush Alphabets for Writing and Lettering*, supplies the following account, which makes another important point about usage: 'writing', he explains, is the making of a letter in the same number of strokes, which may be connected or separate, as the letter has essential parts, while 'lettering' is the making of a letter in more strokes than the letter has essential parts.

'Calligraphy' (from the Greek) means beautiful writing, elegant penmanship or penmanship generally, while a 'calligrapher' is one who writes beautifully, a professional transcriber of manuscripts. The Chinese, who esteem calligraphy more highly than do western cultures and expect more inspiration from the practitioner, would undoubtedly regard these definitions as merely dry bones, however. It was an anonymous Chinese who provided the following insight, which complements the dictionary definitions most illuminatingly: 'The essence of beauty in writing,' he said, 'is not to be found in the written word but lies in response to unlimited change; line after line should have a way of giving life, character after character should seek for life-movement.' (Quoted by Jean Gordon Lee in *Chinese Calligraphy*, 1971.)

Introduction

M ore than twelve years have passed since *Calligraphy Today* was first published and although this may seem a very brief span in the history of so ancient and enduring an art, it is perhaps sufficiently long for a look at the developments since 1963 to be rewarding.

The earlier edition aimed to be an illustrated survey of the tradition and trends of calligraphy since its astonishing revival at the beginning of the century. The illustrations, showing aspects of the work of British, European and American calligraphers, were its principal feature and the success of the book was mainly due to the active co-operation of the many scribes who allowed their work to be reproduced.

Some of the developments to which we looked forward in 1963 have taken place. The craft has enlarged the range and variety of its materials and uses and has gained wider support from public interest. This interest has been particularly associated with handwriting as an expression of personal skill. The various developments of italic handwriting are well known and publicized. The interest has also extended, however, to an appreciation of formal calligraphy as an art form. This is especially gratifying, for a well-informed and appreciative public not only enhances the status of a craft but also helps to create a desire for works of quality.

The demand for a further selection of illustrations to augment those of 1963 has prompted this new edition of *Calligraphy Today*, which it is hoped will prove stimulating to practitioners and also kindle enthusiasm among newcomers to the craft.

If one dared to sum up the principal change in the last decade, one might say that the practice of calligraphy has grown more liberal, more spontaneous and more adventurous. There are works where the author's text is transcribed simply and straightforwardly. Then there are other works in which the written words are used not only to express meaning but also to evoke the mood and spirit of the text. There are also exciting possibilities when letter forms are considered as an abstract art expressed through texture and pattern. This trend follows the influence of Chinese and Japanese calligraphy, which has made a notable impact on the thinking of distinguished modern American painters and can now be seen in the work of some western calligraphers.

Some calligraphers are also illuminators and illustrators and they delight in commissions to produce those rare and precious manuscripts for which collectors compete.

The traditional calligraphic works made for formal and state occasions, which are a feature of the craft in Britain, continue to be in demand even in our technological age. These include charters, Patents of Nobility, Freedom scrolls and presentation addresses, illuminated with all the panoply of gilded heraldic decoration and sometimes hung with wax seals and enclosed in hand-made leather scroll-cases or caskets of precious metal.

Then there is the work that helps to earn the scribe his bread-and-butter: recording names on certificates and inscribing memorials on vellum or wood for chapels, libraries, guildhalls and the like, or lists of benefactors for schools and colleges, or lists of rectors for ancient churches. These are commissions that may be carried out either on mural panels or in book form. In cases such as these, calligraphy is far more appropriately personal than printing or letraset.

What might be described as 'calligraphy for service' continues to expand and flourish in the field of graphic design, with the production of admirable and practical works for reproduction on a modest scale. These include bookplates, letterheads, logotypes and labels, invitation cards, menus, tradecards, record sleeves and TV titles—to name but a few. Work for publication also embraces book jackets, book labels and advertisements. This is a field in which many scribes are singularly adept at combining the written title with graphic design.

John Woodcock Logotypes for use on stationery

In the last ten years the making of exemplars and teaching aids has proliferated and most teachers of lettering and calligraphy now make their own. A number of books on aspects of calligraphy have been published during the same period. These new works may be seen as adding to the earlier books on the bookshelf rather than replacing them; some of the most useful have been included in the Select Bibliography.

In this edition of *Calligraphy Today* an outline of the work of the pioneers has been retained from the earlier edition. This outline covers the activities of Edward Johnston, Rudolph von Larisch, Rudolf Koch, W. A. Dwiggins, and the founder members of the Society of Scribes and Illuminators. Most of the illustrations, however, have been chosen from works completed in the last ten years. These include formal calligraphy by members of the S.S.I. as well as original pieces by Karlgeorg Hoefer, Friedrich Poppl, Arnold Bank, Hella Basu and others. Together they give some idea of the variety and sophistication of contemporary work. Numerous examples from the field of graphic design are included, by American, European and British scribes, and the book also illustrates some alphabet exemplars and teaching aids.

Calligraphy is a difficult subject to define and therein lies something of its richness and appeal. The Greeks had a word for it—'Calligraphia'—meaning beautiful writing. However, the term covers more than the art of formal writing with pen and brush, for it embraces cursive writing too if it has grace and legibility. Added to this is the

dimension of literary content, for words have a meaning and this can impose a discipline upon their form. Like notes in music, letters and words are linear and sequential. The human eye, however, like the ear, can simultaneously absorb different themes, textures and colours when the scale and design are rightly handled.

The alphabet we use, compounded as it is of history, principles and expediency, was invented to record events, honour the gods and transmit knowledge. It is a marvellous instrument and the civilization we inherit is based on written records in all the many spheres of learning.

After speech, the alphabet is the most vital bridge between men, and in literate societies almost everyone is taught to write. In earlier times, when books were entirely made by hand, they were rare and precious and it was normal for the skill of craftsmanship to be expended on the form of the letters and the arrangement and decoration of the page. The letter forms of our western alphabet go back to classical Roman sources and the reed and quill are the ancestors of the metal edged-pens used by modern calligraphers.

The advent of printing changed the making of books and the status of scribes. What relevance has calligraphy in the climate of today's technological society, when machines do as much of the work as hands used to do? The idea is gaining ground that the skilled use of one's hands is an integral part of the 'good life', and mastery of such a skill is a personal enrichment. Calligraphy moreover, has a beauty and a meaning that gives pleasure to many who do not practise the craft themselves, and as the appreciation of fine writing increases, so does the realization of its enhancement of everyday life.

Calligraphy has won a significant if modest place in the graphic arts in Britain. But the future development of the craft depends on the sound teaching of its principles and practice. Writing is a complex subject and there are many questions that remain unanswered. How does one discriminate between good and bad letter forms? By what criteria should calligraphy be judged? And most important of all, how are new craftsmen to be trained in the required techniques?

Many distinguished craftsmen have been self-taught and scribes, in Britain and elsewhere, have acknowledged the debt they owe to Edward Johnston's *Writing and Illuminating, and Lettering* (1906), from which they have taught themselves the craft. The aims and ideals of Johnston were those of the true craftsman. 'The problem before us,' he wrote, 'is fairly simple—to make good letters and arrange them well. Seek for simplicity . . . If our methods are right, the work will grow by nature beautiful.' He set his pupils a simple rule: 'Be true to readableness, to penmanship and to our author.' He also taught that 'within the limits of our craft we cannot have too much freedom'. This was an open invitation to extend the limits of the craft to embrace new ideas, new materials, new purposes, always remembering that freedom in writing should be controlled by disciplined skill and discrimination: mere dexterity with a pen is not necessarily a virtue.

The scribe transmits the author's words, and he may approach them almost impersonally, using line upon line of clear, simple, legible writing, or he may express a more involved attitude to his text by the use of letter forms of exceptional strength or

elegance, or by unusual spacing or irregularity in arrangement, which bring out the meaning of the words and the artist's feeling for the author's intention.

The study and practice of calligraphy is a sound discipline for all who are concerned with letters, whether written, painted, incised, engraved or printed. The shading of letters (that is to say, the relative incidence of thick and thin strokes), the proportions of letters, their spacing and the arrangement of writing on the page, provide a fundamental training for hand and eye. An understanding of historical styles of writing is important as a springboard but contemporary hands should be free from archaism. The nice distinction between hard and soft tool writing and the proper use of instruments—the reed, quill, edged-pen and brushes of various shapes—are technical skills to be mastered. However, technical expertise alone does not produce a notable piece of writing. Unless the scribe is communicating his imagination, a lively grasp of the content of what he is transcribing, and an indefinable sense of *quality*, his calligraphy tends to become merely a vehicle for personal display.

It is ironic that just at the time when public interest in calligraphy has everywhere increased, the craft has lost its proper position in the curricula of art schools in England, and the position seems somewhat the same in Europe and America. There is a continuing and unsatisfied demand for expert teaching in this uncommon craft.

The Historical Background

The revival of calligraphy in this century cannot be properly appreciated without an understanding of the historical styles of writing on which the revival was based. The rediscovery towards the end of the last century of the beauty and discipline of these earlier hands engendered a creative vitality in calligraphers in both Britain and Germany and subsequently in America. A few key examples from historical manuscripts are illustrated in this book, for it is upon these particular hands that many modern styles of writing and type-faces have been based, either directly or remotely.

The traditional letter forms in use today grew by a long process of development and modification. The Roman characters of classic times show clearly the formative influence of the tools used in making the letters. These tools were the flat brush and chisel on stone; the stylus on wax and clay; and the reed and quill on papyrus or skin. The arrangement of thick and thin strokes and the shape of the curves are largely determined by the instrument used in making the letters and the angle at which it is held when writing.

Individual styles of writing have reflected something of the architecture and character of the period in which they have flowered, and the quality of its writing helps to establish our sense of a given period. The Gothic letter—romantic, angular and ornamental—produces an entirely different feeling from the rounded, classic, well-balanced Roman letter, and the graceful cursive hands are in sharp contrast to both.

The perceptive calligrapher, enriched with a knowledge and understanding of the construction of the letter forms which are characteristic of these styles, will not merely copy them slavishly. Instead, selecting a style suited to his purpose, he will develop and adapt it to the occasion, whether it be ceremonial, solemn or festive. He will aim to produce a result which is genuinely contemporary in feeling but based on an understanding of tradition, which acts as the springboard for his own skills.

The principal formal hands used in early book production were written in capital letters or, to use the technical terms, majuscules. These Roman book-scripts generally consist of letters written between two imaginary parallel lines without ascending or descending strokes. In the fourth and fifth centuries A.D., books in the West were written in Square Capitals, a hand clearly derived from the classical Roman

IDALIAELVCOSVBI
FLORIBVS'ETDVLC
IAMQ IBATDICTOP

1

ERRABVNDABOVISVE
AVTHERBACAPTVAIV

2

SALOMONAUTEM
CENUITROBOAM
ROBOAMAUTEMGE
NUITABIAM
ABIAAUTEMGENUITASA
ASAAUTEMGENUIT
JOSAPHAT

3

	1	**Square Capitals**, 4th–5th century. From a Virgil in the Library of St Gall, Switzerland, Cod. 1394
	2	**Rustic Capitals**, 4th–5th century. From a Virgil in the Vatican Library, Cod. Palat. Lat. 1631
	3	**Roman Uncials**, 7th century. British Museum Add. MS. 5463
	4	**Insular Half Uncials** from the Lindisfarne Gospels, A.D. 698, with a gloss showing Insular Cursive. British Museum Cotton MS. Nero D. 1V
	5	**Roman Half Uncials**, ante A.D. 509
	6	**English Uncials**, with a gloss showing Insular Cursive. British Museum MS. Vespasian A. 1

[Image 4: Insular Half Uncials with gloss — text includes "ID ipsum autem", "Glatrones quippi", "erant cum eo", "inproperabant ei", "Asexta autem hora", "tenebrae factae"]

4

NONExtabitinreie· liuerouodeit potiurcorpo
raliterineomanent·diuinitatenaturaeineo
di exdo significat ueritatem·dumineodicere
nonautperdignationem· autperuolumtatem
redpergenerationem· uerui ettoturcorpora
yecundumre plenitudinemanent· dumquod

5

[Image 6: English Uncials with Insular Cursive gloss]

MEMOR FUIT MISERICORDIAE SUAE IACOB
ET UERITATIS SUAE DOMUS ISRAHEL·
VIDERUNT OMNES FINES TERRAE SALUTAREDINI
IUBILATE DO OMNIS TERRA
CANTATE ET EXULTATE ET PSALLITE·

6

inscriptional letters, which themselves have never been surpassed in their grace, proportions and clarity, and of which the well-known Trajan column inscription is an outstanding example.

The Rustic Capitals of the same period were written more freely. The pen was held at a steeper angle to the line, thus compressing the letters more closely together and making the down-strokes of each letter thinner. A third book-hand used by the Romans and also formed of capitals, was the Uncial. The Uncial developed out of Greek into Latin, and was a style of writing with rounded forms and without joins, used in classical and religious manuscripts from the fourth century to the eighth century; it was truly a penman's letter, and so has proved a popular inspiration to the modern scribe.

During this period, when the formal hands were used for writing books, the Roman informal or cursive writing was developed from the capital letters and used for documents, letters and similar commonplace purposes. It was natural for scribes when writing at speed to alter the formal shapes of letters to economize on effort. These more freely written forms eventually became known as 'minuscules' or small letters, as distinct from 'majuscules' or capital letters. Subsequently, when printing was invented, minuscules were called lower-case, a usage which continues today. The term derives from the two compartments in the compositor's frame in which his type is kept: the upper case, containing capitals, and the lower case, containing small letters.

To a blending of the Roman cursive everyday hand with the Uncial script letter we owe the development of the Half Uncial during the seventh century, marking an important step in the history of writing. From now onwards the small letters, with the introduction of ascending and descending strokes, are made between four imaginary lines instead of two and the pen is held with its edge straight to the line of writing.

All countries under the rule of Rome adopted these hands. The formal book-hands did not alter greatly in the course of time but cursive writing developed marked national characteristics of its own in Italy, Spain, France and England.

The coming of Christianity to Ireland in the fifth century brought the culture of Europe to that remote country and the Irish Half Uncial emerged, to be seen at its best in the incomparable *Book of Kells*, which was written in the eighth century. From Ireland Christian culture spread to Iona and Northumbria, where the English Half Uncial, which is a round hand, developed. The magnificent *Lindisfarne Gospels*, completed in A.D. 698 and subsequently found in the coffin of St Cuthbert, is the outstanding work written in this style.

The English Half Uncial was the first style of writing to be modernized by Edward Johnston and used as a copy-book for his students. He said of it that

'its essential roundness and formality discipline the hand. Its elegance has an aesthetic value that fits it for certain manuscript work, but unfits it for practical uses where thin parts are likely to damage (e.g. as a model for type or letters formed in any material, or to be read at a distance). It is in effect the "straight-pen" form of the "roman" small letter (that is, practically, the Roman Half Uncial). It therefore represents the ancestral type of small letter, and is a good basis for later hands.'

1 **Roman Capitals, Uncials** and
Carolingian Minuscules from the
Alcuin Bible, Tours, 9th century.
British Museum Add. MS. 10546

2 **English 10th-century hand.**
From a Psalter written in southern
England about A.D. 975. British
Museum Harl. MS. 2904

3 **Gothic** 13th-century writing.
British Museum Egerton 2569

4 Terence's *Comedies* written in
Humanistic script by Gherardo
del Ciriagio, 1466. Bodleian MS.
E. D. Clarke 28

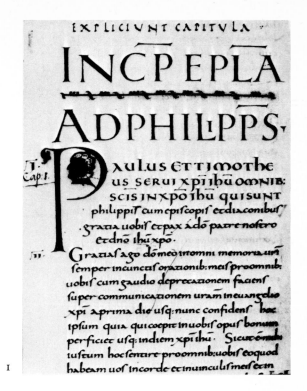

17

In the history of handwriting the Age of Charlemagne is of far-reaching importance. In A.D. 789, the Emperor Charlemagne, who so greatly influenced the religious and cultural life of his time, decreed the revision of Church books. This intensified activities in the monastic writing schools in France. Alcuin of York was given the key appointment of Abbot of the Monastery of Tours, where he remained for eight years until his death in 804, and where he encouraged the development of the clear, fluent script which came to be known as the Carolingian Minuscule. In its earliest form this script has features that are cursive, such as a slight forward slope, and some of the letters made without pen lifts between the strokes. It is a hand of outstanding rhythmical beauty and importance; our lower-case printed letters of today derive from it, and for centuries it remained the dominant hand of the West.

During the tenth century a particularly fine variation of the Carolingian Minuscule came to be used in southern England. The emergence of this hand was the result of the Benedictine revival of learning, which led to a significant increase in the making of books. It was a strong hand of developed formality, and Edward Johnston considered it an almost perfect model for formal writing. He wrote a modernized version of it using an edged-pen, which he called the Foundational Hand.

By the twelfth century in France and England the Carolingian script was on the way to becoming Gothic. The thirteenth-century Gothic hand was compressed, with pointed and broken letters, and although rich in pattern when seen at its best, it is a tiring script to read. Gothic styles in Germany have persisted into this century but are now in retreat.

In Italy neither architecture nor letter forms pursued the Gothic impulse to the full; both retained their rounded features. The humanist scholars of the Renaissance, searching for works of the classical authors, came upon manuscripts written in the Carolingian hands of the eleventh and twelfth centuries; this style they termed 'littera antiqua' and adopted it for their own use. The Renaissance versions of Carolingian hands are called Humanistic. In addition to their interest in manuscripts the humanists also observed and copied the classical Roman inscription letters and adopted them for writing, lettering and type. It has been fortunate for Britain that the dominant typefaces have followed these Italian styles.

Printing with moveable type had been invented in Germany, probably by Gutenberg, about the middle of the fifteenth century, and the early German types were based on the formal Gothic book-hands. In Italy, however, type-faces were inspired by the open and more legible styles of the revived Carolingian Minuscule and the Roman capital letters. It is hard to imagine more noble models for the design of type-faces at the outset of printing, and it is understandable therefore that the early printed books were modelled on manuscripts.

During the Renaissance in Italy a variant of the Carolingian hand was developed which we know as Italic. Its characteristics were those of a cursive hand, the result of speed, rhythm and economy of effort. It was used in manuscript books and in correspondence and for the numerous Papal briefs sent all over Christendom, and by the end of the fifteenth century it was known as 'cancellaresca'. It also became the model for various italic type-faces.

The first Writing Book, *La Operina*, was produced in Rome in 1522 by Ludovico degli Arrighi of Vicenza. This work offers instruction in using the cancellaresca hand and is printed from engraved wood-blocks; it has been a source of inspiration to many modern calligraphers. Arrighi followed *La Operina* a year later with a second book of model hands, *Il Modo*, and in 1524 and 1544 Writing Books were published by Tagliente and Palatino. The popularity of these aids to good writing encouraged similar exemplars to be produced in other countries. The modern revivalists have continued this excellent practice.

In the development of letter forms the craftsmanship of scribes has played a significant part, but the brush, the graver and the flexible nib also influenced the letter forms which printers developed when they took over the responsibility of book production.

The earliest aim of the printer was to produce books resembling as closely as possible manuscripts written in the formal hands of the period. Later the wheel came full circle: handwriting became devalued when, with the aid of the pointed flexible metal nib, it attempted to imitate the style of lettering used by engravers for printing. This debased style, known as copperplate, offered an opportunity for enjoyable virtuosity and some calligraphers still succumb to its period charm.

By the end of the nineteenth century the creative arts and crafts were at a low ebb and the standard of both type design and book production had seriously deteriorated. It was around this time that the revitalizing influence of both John Ruskin and William Morris began to be felt.

The Revival of Calligraphy in Britain

William Morris was born in 1834 and died in 1896. He was a poet, romance writer and a Socialist, and also became a master of many crafts. Indeed he was the father of the Arts and Crafts Movement, which was born of the political and artistic aspirations of that period, and took the form of a revolt on a practical level against the shoddiness of the products of the Industrial Revolution.

Morris made designs for wallpapers, glass, textiles, tapestries and print. His sense of craftsmanship soon led him to the study of old manuscripts, and he himself owned several early examples, among them a unique variant of Arrighi's *La Operina* and *Il Modo* in one volume. Between the years 1870 and 1876 he experimented with writing and decorating books in the style of the medieval and Renaissance scribes. In his note on the manuscript work of William Morris, Alfred Fairbank writes: 'Morris could well be described as a complete bibliophile: author, scribe, illuminator, engraver, type designer, printer, publisher and collector.' His manuscript books are few in number and some remain unfinished, but each of them is a work of art; among them are a Horace (now in the Bodleian Library, Oxford), a Virgil and two copies of Omar Khayyám. Some of these were exhibited in the first exhibition of the Arts and Crafts Exhibition Society in 1888. Morris used various scripts, mainly semi-formal and cursive Roman hands showing a rhythmical quality, but he never acquired a true understanding of the shapes of letters and their inner relationships. Nevertheless his own manuscripts lead into the calligraphic reforms of the twentieth century, and through his studies and experiments he opened the way to the calligraphic revival. In 1890 Morris founded the Kelmscott Press at Hammersmith, together with Emery Walker, who was a typographical expert, a process engraver and an antiquary. In many ways the Kelmscott Press was the crowning achievement of Morris's life. For it he designed type founts, ornamental letters and borders. Fifty-three books were produced by the Press, of which the most famous is the *Chaucer*. Morris and T. J. Cobden-Sanderson, who founded the Doves Press in the same year, between them raised the standard of book production from the low state into which it had fallen. Following their success, other private presses were started in England and in Europe; many of the books produced were outstandingly beautiful and calligraphers were commissioned to design type for them and decorative or written initial letters.

Cobden-Sanderson was himself a binder and printer and a pioneer in the Arts and Crafts Movement of the 1880s. In his treatise *The Book Beautiful* he emphasizes the fact that Morris was a calligrapher and an illuminator before he became a printer. However, the influence Morris exerted was greater in the field of printed books than in manuscripts. His ideals of simplicity, beauty and fitness in the crafts were much in advance of his period. Ruskin said of him, 'Morris is beaten gold—the most versatile man of his time.'

In their formal writing Victorian penmen used a form of Gothic script. With a fine-pointed steel nib they painstakingly drew skeleton letters which they then filled in with a brush. It is not surprising therefore that the writing in medieval manuscripts was thought to have been carried out in a similar way by cloistered monks or scribes set to copy sacred books slowly and laboriously for prelates and princes. The theory and practice of penmanship was little known when Edward Johnston began to study the pen shapes of letters in the British Museum.

Edward Johnston, c.b.e., was born on 11 February 1872. In 1897 he turned from the study of medicine at Edinburgh, because of delicate health, and from then onwards devoted himself to the study and practice of formal penmanship until his death on 26 November 1944.

Johnston was fortunate in having the help and advice, at an early stage of his career, of W. R. Lethaby, Sydney Cockerell and Robert Bridges. Sydney Cockerell, later Sir Sydney Cockerell, had been William Morris's secretary and was himself an authority on illuminated manuscripts. It was he who pointed out to Johnston the finest examples for study in the British Museum and told him of Morris's own researches and experiments. Johnston carried out his own enquiries with the perception of a craftsman and the perseverance of a scientist and philosopher. He rediscovered the principles on which formal penmanship had been developed, the writing instruments and materials used and their correct preparation. He discovered that the nature and form of a letter were determined by the nature and form of the pen that made it, that an edged-pen makes thick and thin strokes according to the direction and angle at which it is held and not according to pressure, and that the size of the letter is in direct ratio to the breadth of the edged-pen making it. He rediscovered how to cut and sharpen reeds and quills, the angle at which to trim the chisel edge of the pen and how to hold the pen in relation to the horizontal line, in order that it should make the desired shapes of the letters when writing. He experimented with the preparation of the surface of skins on which to write, and also with inks and pigments. It is difficult to realize, now that these technical facts are well known to every student of calligraphy, that they could have been so completely lost. Their rediscovery was momentous for craftsmen and writers.

In 1899 Johnston was asked by Professor Lethaby to take a class in 'Illuminating' at the newly formed London County Council Central School of Arts and Crafts, which was then in Upper Regent Street. Lethaby had been a young friend of William Morris and had played a part in initiating the Arts and Crafts Movement. He helped to establish firmly what others had already begun, and a whole generation of craftsmen owe to him their training in this fine tradition.

Johnston's class started with seven or eight students, among them: T. J. Cobden-Sanderson, who was considerably older than the others; Eric Gill, then a very young man who subsequently became renowned as a sculptor, engraver and letterer; Noel Rooke, who later engraved illustrations for Johnston's *Writing and Illuminating, and Lettering*; Douglas Cockerell's wife; and Emery Walker's daughter. Within a year their number had increased and included Louise Lessore (who married Alfred Powell), Graily Hewitt, Lawrence Christie, Percy Smith and Florence Kingsford, who became known for her illuminations and who married Sydney Cockerell. Priscilla Johnston, in the biography of her father, *Edward Johnston* (1959), says that these early students had 'every reason to regard themselves as pioneers. Together they were a band of explorers in an unknown country . . . Johnston's goal at this time—even more than to establish himself—was to establish the craft. He envisaged a sort of guild of calligraphers, all studying, experimenting and making discoveries which they would then all share.'

A short-lived Society of Calligraphers was formed, of which Percy Smith was the Honorary Secretary with Eric Gill, Edward Johnston, Philip Mortimer and Allan Vigers making up the executive.

In 1901 Johnston started his classes at the Royal College of Art at South Kensington, where Lethaby had been appointed Professor of Design. It was an entirely new idea for writing and lettering to form an integral part of art education. Johnston's classes soon became full and he had to devise for his students a means of mass instruction: He illustrated his lectures by remarkable blackboard demonstrations which were an inspiration to all who attended them. Fortunately this valuable teaching, committed to the fugitive medium of the blackboard, was recorded by one of his students, Violet Hawkes, who with great foresight took photographs of them. Johnston also used instruction sheets which he wrote himself in hectograph ink and by this means reproduced the limited number of copies required. Later the Pepler sheets, partly written by hand and partly printed, were produced for the use of his students.

In the early years of the century only Edward Johnston and Graily Hewitt had sufficient knowledge of calligraphy to teach the subject, and when the Birmingham College of Art wanted to start a class, Ernest Treglown came to London especially to learn from Johnston. Before long the Leicester College of Art had a lettering class, and in time the subject became an integral part of the curriculum in many art schools.

In 1906 Johnston's manual *Writing and Illuminating, and Lettering* was published. This classic textbook is still indispensable to students of calligraphy and to all who are interested in the theory and practice of the craft. Sir Sydney Cockerell said of it:

'Johnston's handbook is a masterpiece, immensely instructive and stimulating. And not only technically helpful, for the reader is conscious all the time of being brought in touch with a rare and fine spirit. *Writing and Illuminating, and Lettering* won him disciples and followers not only in this country but in Germany, where he had a powerful advocate in one of his best pupils Anna Simons, in America and even as far afield as Australia.'

In 1909 a portfolio of *Manuscript and Inscription Letters* was published for schools and for

the use of craftsmen. The sample alphabets were based upon Johnston's earlier class sheets and included plates by Eric Gill.

All his life Johnston searched for truth in his work. He analysed and experimented with each important historic style of writing in turn, until he became familiar with the shapes and relative proportions of the letters and had a complete understanding of how to manipulate the edged-pen in order to make these styles his own.

He taught his first pupils Uncials and Half Uncials and soon added—to the surprise of his students who thought they had learned all there was to know—his slanted-pen writing, adapted from tenth-century hands, especially that of the Ramsey Psalter, now in the British Museum. This style, which was later to become his 'Foundational Hand', as Johnston termed it, was the basis of his teaching and the principal formal hand he used in his own work. These styles were followed by built-up Versals, Roman capitals, Roman small letters and versions of the Foundational Hand which he called 'Italic', made by compressing and slanting the letters. Towards the end of his life he experimented with a sharpened italic which was Gothic in form.

Johnston's own work as a craftsman was much sought after. He was commissioned by public bodies and private patrons to make presentation addresses, rolls of honour, service books, wedding gifts and the like. Among these undertakings were a Communion Service for a church in Hastings, a Coronation Address to King Edward VII and scrolls for the Worshipful Company of Fishmongers. His output was small and his problem was always to get the work completed on time. Probably the most important and largest manuscript book he ever undertook was the Keighley Roll of Honour, which was written in 1924, but most of the manuscripts he made were in the form of small booklets. His commissioned works were usually magnificent broadsides, or vellum panels, decorated with heraldry and burnished gold leaf, such as the Freedom Scrolls for the Livery Companies of the City of London. His writing has an inner vitality which came from his genius for combining and contrasting size, form and colour to make a unity of the whole. His pen strokes are sharp, direct and swift. The letters display an architectural quality, and above all they reflect his integrity, for he aimed at nothing less than perfection; as a result he was always finding fault with his own work, which rarely matched his ideal concept.

Between the years 1910 and 1930 Johnston designed initial letters and types for Count Harry Kessler of the Cranach Press in Germany. In 1916 he was commissioned by Frank Pick to design a special type for the use of the London Transport Services. The result—Johnston's sans-serif—was a block letter alphabet based on classical Roman proportions. It was the forerunner of many sans-serif founts, including that of his pupil and friend Eric Gill, whose Gill Sans type was designed some years later for the Monotype Corporation.

Johnston revealed his unparalleled genius as a scribe in his own work. As a teacher he exerted an immense beneficial influence upon letter forms in England and in Europe, especially in Germany, and it was not long after the publication of *Writing and Illuminating, and Lettering* that its impact was felt in America. The founding of the Society of Scribes and Illuminators in England was another outcome of his teaching. Sir Francis Meynell said of him, 'He was one of the few really great men of our time.'

William Graily Hewitt, O.B.E., was born in 1864 and died in 1952. He studied law and was called to the bar in 1889, but finding no satisfaction in his profession he turned to penmanship and the study of early manuscripts comparatively late in life. On the advice of Sydney Cockerell he became one of Johnston's first pupils, and in 1901 he succeeded him at the Central School of Arts and Crafts, where he taught calligraphy for more than thirty years. In his teaching he developed Johnston's methods, but he was essentially a book scribe and his outlook was different, his particular interest lying with the Italian Renaissance styles of writing.

After the First World War he and his assistants prepared many memorials, mostly in manuscript form, for public schools, Inns of Court, regiments, public companies and the House of Lords. He also wrote out the Letters Patent of Nobility and other important documents for the Crown Office and the Home Office.

Graily Hewitt's greatest achievement was his recovery of the craft of laying and burnishing gold leaf. The illuminated pages of medieval manuscripts owe much of their magnificence to the brilliance of pure gold leaf, which may still retain its beauty and burnish after hundreds of years. When the art of formal writing declined, following the invention of printing, the allied crafts of illuminating and gilding manuscripts deteriorated also, and the relevant skills were lost. With the revival of calligraphy at the beginning of this century the opportunity for the use of burnished gold and illumination returned. Hewitt conducted a series of experiments over many years in order to rediscover the composition of the gesso used under gold leaf as a raising preparation, and he based these researches on the frequently obscure recipes and directions of Cennino Cennini. The unsurpassed gilding on Hewitt's own manuscripts, some wholly written in the gesso and gilded and burnished, testify to the success of his preparations and to his skill in using them. His methods are described in detail in his own book *Lettering* and in the chapter on gilding he wrote for Johnston's *Writing and Illuminating, and Lettering*.

Hewitt admired the Humanistic manuscripts of the fifteenth century and particularly those of Antonio Sinibaldi and Johannes Andreas de Colonia. It was from these fine Humanistic scripts that some of the elegant early printing types derived.

Hewitt developed a style of illumination which grew out of the initial letter and which itself was often of burnished gold leaf. He also took the so-called 'white vine' illumination of the fifteenth-century Italian manuscripts as a model for ivory-coloured scroll work set against panels of jewelled colours. He aimed at a style of illumination that, while allowing of some variation, would yet be consistent throughout a manuscript and also be adaptable enough to fit any space. He used decoratively English trees and shrubs, such as the oak with gilded acorns, the chestnut, beech, rose and ivy. These were used for the solid decoration, to which he added a filigree of simpler flower forms, such as speedwell, clover, pimpernel and bindweed, enlivened with butterflies and birds. This manner of illumination was exquisitely carried out to his design by Madelyn Walker and Ida Henstock, and by others who worked with him. Graily Hewitt and his assistants came close to the medieval concept of a scriptorium or team of craftsmen, each contributing his skill to the making and decorating of fine manuscripts so that the product was the fruit of a close collaboration.

Hewitt's *Oxford Copy Books*, which were published in 1916, were a new attempt to provide a model for everyday handwriting. The style is a fine italic script based on sixteenth-century hands, but the letters have no joins and it is not truly a cursive hand. In 1932 Hewitt's *Treyford Writing Cards* were published and in 1938 his book *Handwriting: Everyman's Craft* appeared. When he retired from teaching Graily Hewitt formed the Manuscript Club, where his former students and others involved in the subject met for discussion on matters of common interest.

Italic Handwriting

In the wake of Edward Johnston's teaching the increased appreciation of good lettering led naturally enough to a critical reappraisal of the standard of everyday handwriting. The virtues of the cursive italic hands of the Renaissance and their suitability for modern use began to be recognized.

Before the end of the last century William Morris had already attempted to use an italic script in some of his own manuscripts. Mrs Bridges, the wife of Dr Robert Bridges the Poet Laureate, had published *A New Handwriting For Teachers* in 1898. This was one of the first of such protests against bad handwriting and contained an Italianized Gothic hand, or italic as it would be called today. Edward Johnston himself included an italic hand among the illustrations to *Writing and Illuminating, and Lettering*, published in 1906. He thought it showed possibilities for improving the standard of current handwriting, which he felt would be one of the most practical benefits to arise from the study of calligraphy.

After the First World War considerable research was made into the Humanistic scripts by palaeographers, typographers and calligraphers, among them Professor B. L. Ullman, Stanley Morison, James Wardrop, A. F. Johnson and Alfred Fairbank. The variety of these interests led to a broader appreciation of italic, and the revived use of italic handwriting began to gain ground among enthusiasts, although until recent years the teaching of it in schools remained slight.

Alfred Fairbank, C.B.E., who had been a pupil of Graily Hewitt and Lawrence Christie, was attracted by the formal book-hands at first, but as early as 1923 he began to take a particular interest in italic scripts. The result of these early researches and his own experiments with these styles led to the publication in 1932 of the *Woodside Writing Cards* and in 1935 of the *Barking Writing Cards*, which subsequently became known as the *Dryad Writing Cards*. These exemplars illustrate a model cursive hand allowing the use of joins. Among the historical influences in forming them were the sixteenth-century writing manuals of G. A. Tagliente, who was a Venetian, and F. Lucas, a Spaniard. These Writing Cards, together with the edged dip-pens he had had made for the purpose, became a practical basis for teaching italic in schools.

In 1932 Alfred Fairbank's book *A Handwriting Manual* was published, introducing the italic hand to a number of schools in Britain. This manual was the forerunner of a

wave of books on italic handwriting, and is still today the outstanding work on the subject, both for the teacher and for the individual who seeks to remodel his writing in the italic style. Its influence has been widespread on both sides of the Atlantic—Americans, it is worth noting, are particularly attracted to the italic hands.

The range of Alfred Fairbank's interest and research is shown in *A Book of Scripts*, published in 1949, which later became a Penguin bestseller, and the more comprehensive book *Renaissance Handwriting* which he compiled with Berthold Wolpe. The notable part he has taken in promoting italic handwriting has possibly obscured a full appreciation of his skill as a calligrapher. The manuscripts he wrote and gilded for Mr St John Hornby and others between the years 1924 and 1939 are unfortunately seldom seen today. These elegant and dignified books were written on vellum in roman and italic hands in leisure time from his professional work in the Civil Service. They are the fruit of a successful collaboration with Louise Powell who did the illuminations, an artist whose visual imagination was so strong that she could paint directly onto the page without making a preliminary drawing. Fairbank's interest today is in the teaching of italic handwriting in schools but his related influence on scribes, especially in America, has been significant. In honour of his seventieth birthday he was presented in 1965 with a volume of essays, *Calligraphy and Palaeography*, edited by Dr A. S. Osley, and the enthusiast will find much to stimulate and interest him among the scholarly contributions it contains.

It was in 1952 that Alfred Fairbank, at that time President of the Society of Scribes and Illuminators, encouraged the formation of a new society to focus public interest in the reform of handwriting in general and the adoption of a contemporary italic script in particular. In that year the S.S.I. founded the Society for Italic Handwriting, with Joseph Compton as the first Chairman and Anna Hornby as Honorary Secretary; two years later the Marquess of Cholmondeley accepted the office of President. The Society was to be a forum for discussion and lectures, and a means of assistance both to people seeking to remodel their handwriting and above all to teachers in schools, with the aim of raising standards always in mind. The new Society rapidly gained a wide international membership and its scope and influence increased. Branches of the S.I.H. grew up in America and elsewhere.

Today the world-wide membership of the S.I.H. is linked by the *Journal* edited by Dr Osley, which not only keeps members in touch but is sent to various universities and libraries here and abroad. In addition to spreading the use of modern italic, the Society is concerned with research into the origin and development of italic during the Renaissance.

Books on italic handwriting abounded in the fifties and sixties when interest in the subject was at its height, and many young people began to use the hand. A complete system of teaching italic was developed in the *Beacon Writing Books*, of which Alfred Fairbank was editor and calligrapher. Since then there has been something of a reaction against the use of italic, partly because of a misconceived idea that it is not a practical hand for everyday use, and partly because the pendulum has swung against too ardent an advocacy, but the main reason for its decline is the difficulty of training teachers.

Within the past decade, however, the Swedish government decided on the use of the Humanistic curvise as a model for school handwriting. A recent reform in teaching handwriting in East German schools has also been founded on italic letter forms. And in America Professor Lloyd Reynolds, who has had success in Oregon with the teaching of italic in schools, considers that in the Pacific North West there is considerable evidence that it helps students in their other studies, in the sense that what may be regarded as poor work in fact seems poor only because it is badly written.

The italic scripts most widely used by scribes today fall into two categories: those that derive from Edward Johnston's teaching and those that derive from Italian Renaissance scripts. Johnston's italics were developed ultimately from his Foundational Hand and like other formal book-hands the letter forms require many pen-lifts. On the other hand, cursive italic in its *set* form, deriving from the scribes and writing masters of the Renaissance, is as precisely made as the Johnstonian italic but has fewer pen-lifts. It is used for various practical purposes for its beauty and fitness, as well as being a copy-book exemplar. In contrast, the *free* cursive italic, with use of many joins between letters, is primarily a legible and rapid hand, which offers a graceful alternative to slipshod and unconsidered styles of handwriting. Many schoolchildren and adults find the genuine pleasures of craftsmanship in adopting this hand for their everyday use.

Elements of the Craft

An appreciation of the elements of calligraphy and a knowledge of the technique of the craft are of first importance. The form and construction of letters can only be properly understood by using the tools of the craft. The metal edged-pens which are used extensively today are generally inferior to well-prepared quills, which remain the best instruments for formal writing but are now difficult to obtain. Metal edged-pens, both straight and oblique, are made in a wide range of sizes for right- and left-handed calligraphers and they need to be kept sharp and clean if they are to make true and crisp strokes. Inks must flow easily without clogging in the pen, and a good soluble carbon ink is the best in this respect. On the whole waterproof inks are too thick and gummy to flow easily. Good quality paper with an unglazed surface makes a suitable writing material for ordinary use. If the paper is too smooth the pen will slide over the surface uncomfortably; if it is too rough the freedom of the pen is in danger; and if it is too porous the ink tends to feather and spread. Well-prepared vellum gives the perfect writing surface for the practised scribe. All who want to acquire a formal hand have the advantage of one of the most comprehensive handbooks ever compiled for craftsmen in Edward Johnston's *Writing and Illuminating, and Lettering*, first published nearly seventy years ago. *The Calligrapher's Handbook*, published in 1951, is a useful sequel, and *Formal Penmanship*, published in 1972 (Edward Johnston's centenary year), illustrates the later teaching of that master craftsman.

In analysing a formal hand, whether an historical or contemporary example, the following points should be observed: the general appearance of the page and the pattern of the lines of writing, which may be delicate or strong in texture; the pattern made by the ascending and descending strokes, which are sometimes flourished into the margins and used as a decorative feature; and the relative proportions of the text and margins to the page. It is also interesting to observe the method of spacing the lines, whether they are ruled in a block of lines of equal length (as for prose), in columns (for lists of names), or in lines of unequal length (for poetry). The lines of writing may be closely spaced and lines of capitals may actually touch one another to make a close-knit pattern; alternatively the lines of writing may be spaced wider apart than the average to give an open, airy texture to the page.

The average height and weight of a minuscule letter is four and a half nib-widths. The O is the key letter of the alphabet in formal writing; see whether it is round,

compressed, angular or elliptical in shape. Are the letters upright or sloping, joined or separate? Are the thin strokes horizontal or oblique? What is the angle of the thin stroke to the horizontal writing line? Does the script give the impression of strength or stability, elegance or movement, richness or delicacy?

An appreciation of penmanship is greatly enhanced by an understanding of the elements involved in producing a beautiful piece of writing. The calligrapher's concern is to write fluent and legible letters, to space them well to make words and lines, and to arrange them on the page significantly. The spaces inside each letter (the counters) are as important as the spaces between the letters and the words. The ability to space well comes by practice and the experienced calligrapher spaces by eye. A trained eye can also recognize whether a script is sound in the construction of its letter forms. Analysis of fine penmanship will help to develop this kind of discrimination.

Edward Johnston taught that the *desirable* qualities of good writing are Legibility, Beauty, Character. The *essential* qualities are Simplicity, Distinctiveness, Proportion. And the qualities of formal penmanship are Unity, Sharpness, Freedom. In judging all these qualities, however, legibility is fundamental, and it is a term that is difficult to define. Robert Bridges held that 'True legibility consists in the *certainty of deciphering* and that depends not on what any one reader may be accustomed to, nor even on the use of customary forms, but rather on the consistent and accurate formation of letters.' Each letter has distinct characteristics of its own, but all letters in a given alphabet should have a family likeness which makes for unity. Contrasts in size of writing, styles of writing, in colour and in decoration, add interest and liveliness to the page, but they should add to, not distract from, the unity of the whole. The fundamental construction of letters, their proportions and their derivation, should be understood, as these give letters their characteristic shapes. The factor of legibility will to a large extent depend on the unity and rhythm in the writing, qualities which come with knowledge and practice. Rhythm and proportion together make for unity and distinctiveness.

Johnston's third triad—*Unity, Sharpness, Freedom*—is concerned with technique in formal writing. Sharpness results from a well-cut or well-sharpened pen writing on a well-prepared surface. If attention is paid to these technical matters, the pen can be used freely with a sensitive touch to make fluent letters. Writing at the appropriate speed gives rhythm and vitality to the work. Writing that is laboured will lack these qualities, however carefully each letter is formed in itself.

The first duty of the scribe is to the thought or image intended to be communicated by the author of the work being transcribed. The thinking and planning must obviously take place before the writing begins. If the scribe is hampered by technical considerations, or consciously seeks to display his own skill, the work will have neither simplicity nor distinctiveness. Frederick Warde held that

'Calligraphy may be defined as the writing of a person who has trained his hand, his eye and his judgement to write habitually according to a rational method, and that it is most admirable and interesting when it has been done according to its classic rules . . . The rules aim at one objective—FORM . . . Real style is impossible without form.'

Calligraphy in Britain Today

Adirect outcome of the teaching and practice of Edward Johnston was the formation in London in 1921 of the Society of Scribes and Illuminators, through the initiative of Louisa Puller. In its early days the Society was a student body composed mainly of those associated with the Central School of Arts and Crafts, where Graily Hewitt and Lawrence Christie were teaching. The early records show that the Society was founded for

'the advancement of the crafts of Writing and Illuminating by the practice of these for themselves alone; . . . the aim of the Society should be zealously directed towards the production of books and documents wholly hand-made; regarding other application as subordinate, but not excluding it.'

When the Society instituted Honorary Membership by invitation 'to those who have assisted in the advancement of the crafts, or who have been of service to the Society', it was obvious that Edward Johnston should be elected the first Honorary Member. He continued to be the inspiration and mentor of its members and many have followed his methods in their own work.

In the early years research groups were formed which carried out useful technical experiments. A unique and valuable Record Book was kept, in which the findings of these experiments and the resulting discussions were recorded. In 1956, the fiftieth anniversary of the publication of *Writing and Illuminating, and Lettering*, a book of essays on various aspects of calligraphy and illumination was published. This was *The Calligrapher's Handbook*, edited by the late Rev. C. M. Lamb, who was for many years Honorary Treasurer of the S.S.I. The contributors of the essays were all members of the S.S.I. who were writing from their own experience and expertise. It remains a comprehensive guide for the modern student of calligraphic crafts.

Many distinguished lecturers have addressed the Society's open meetings, not only on calligraphy and illumination but also on such related subjects as heraldry, palaeography and the like. General meetings with technical discussions are held annually.

Over the years important exhibitions have been organized by the Society in England, Europe and America. In 1930 and 1938 exhibitions were held in the U.S.A. at the invitation of the American Institute of Graphic Arts and were shown in New

York, Boston and Chicago, as well as the Universities of Yale and Pittsburgh. In 1931 work was sent to the Salon International du Livre d'Art at the Petit Palais des Beaux-Arts in Paris, and in 1932 calligraphy was shown in Copenhagen at the British Industrial Art Exhibition. In London exhibitions were organized by the Society in 1931 at the Victoria and Albert Museum, and five years later at the Architectural Association. A series of notable exhibitions of calligraphy and illumination were held in 1951, 1956 and 1961 at the Crafts Centre of Great Britain. Today the Society is a body of professional calligraphers, many of whom were taught either by Edward Johnston himself or by his pupils. Among those who have carried on the Johnstonian teaching methods are Dorothy Mahoney, Irene Wellington, Margaret Alexander and Daisy Alcock, and others, such as T. W. Swindlehurst, Mervyn Oliver and Rosemary Ratcliffe, who have since died.

The fiftieth anniversary of the foundation of the Society of Scribes and Illuminators was celebrated in June 1971. An animated gathering of some hundred and fifty members and guests was presided over by Sydney M. Cockerell. Professor Julian Brown proposed the toast of the Society, to which Anthony Wood replied. Alfred Fairbank and Alice Hindson spoke in detail about the early days; Irene Wellington gave a tribute to Edward Johnston; and Sir Theodore McEvoy spoke about the Society for Italic Handwriting.

It was particularly appropriate that an exhibition to celebrate Johnston's centenary in 1972 should have been held at the Royal College of Art in London, where he had taught for so many years. It covered all aspects of his work and was well attended, arousing considerable interest among viewers of all ages. The centenary was also marked by six lectures on calligraphy at the Victoria and Albert Museum.

The previous year had seen the publication of *Formal Penmanship and Other Papers*, Edward Johnston's unfinished project for his second book. This important work, edited by Heather Child, contains the essence of his perceptive research into the pen-shapes of letters and the fundamental principles of his later teaching.

Probably the most outstanding feature of the work of calligraphers in Britain today is the production of ceremonial works for public and private bodies for the expression of honour and appreciation. Formal occasions call for formal scripts and relevant decoration, for which the pomp of heraldry and the richness of burnished gold are frequently appropriate. A high level of technical skill has been reached in these unique works and many of them are transcribed on vellum in the form of manuscript books, scrolls or broadsides. In this field certain members of the S.S.I. transcribe and illuminate ceremonial documents for the Crown Office and the House of Lords.

While most calligraphers carry out their own decoration, there have been notable collaborations between scribe and gilder and scribe and illuminator. Two of the most outstanding examples have been the Rolls of Honour for the Royal Air Force and for the American Air Force, at St Clement Danes Church in London, a project undertaken by thirteen members of the Society under the direction of Alfred Fairbank. Illustrated in this book is a page from the Lifeboat Service Memorial Book, completed in 1974, on which five members of the S.S.I. have worked together (page 65). The challenge to the scribe, when called upon to produce work in which the calligraphy must be allied to

decoration, is to reconcile spontaneity of writing with decorative precision and finish while at the same time preserving the unity of the work as a whole.

The Johnstonian school of calligraphy to which this author belongs is traditionally concerned with precision in writing, and calligraphy in Britain has for many years reflected this concern. The fluent calligraphy and sensitive touch of Irene Wellington and Joan Pilsbury, and the variety and precision of Dorothy Mahoney's work, are well known and admired. There are other aesthetic qualities which are equally valuable, and the current climate of thought has encouraged a more unconventional, asymmetrical arrangement of text and in letter forms the spontaneous, almost painterly use of brush or pen. Traditional proportions of margins and line-spacing have given way to greater freedom in texture and layout. In the struggle for creative expression, however, it is important that valuable traditional skills be cherished as they deserve and not sacrificed to fashion.

Calligraphy is a slow, diligent craft; distinguished work requires great skill and professional scribes are few in number. Nevertheless there are calligraphers in Britain today who are producing individual manuscripts of quality and originality with pen and brush, among them Donald Jackson, David Howells, Ann Hechle, Alison Urwick, Hella Basu and Charles Pearce.

Such excellence and control are difficult to attain. The pupil must learn first by copying what he sees demonstrated by the teacher, especially where manual dexterity is the aim. Until he has mastered sufficient skill of hand and eye he is not free to experiment. Johnston's great reputation as a scribe and teacher made it easy for the pupil to adopt his personal scripts, his choice of historical models and his emphasis on precision. However, the questing student should also seek to emulate Johnston's ardour and enterprise in searching out other alphabets and letter forms.★ For inspiration and new stimuli he should venture outside the dominating Roman forms and study the archaeological records of other cultures, on inscriptions, on stelae and in very early manuscripts, as well as the more fully documented medieval period from which Johnston drew.

The profound understanding of calligraphy as an art form in the cultures of the East, notably in China and Japan, has been an influence on certain western calligraphers in the past ten years and it will be interesting to follow this trend in the years ahead. Arabic scripts too, both carved and written, are of outstanding beauty, especially in their architectural use as mural decoration, and are a potential source of fresh ideas.

★See Edward Johnston, *Formal Penmanship and Other Papers*, ed. Heather Child (Lund Humphries, London, 1971), p. 128.

Calligraphy in Europe

Concurrently with the calligraphic movement which was taking place in England at the beginning of the century, similar but independent movements were beginning in Europe. The chief exponents of these far-reaching reforms in writing, besides Edward Johnston in England, were Rudolph von Larisch in Vienna and, rather later, Rudolf Koch in Germany. The aims of these men were to improve the standard and quality of the arts of writing and lettering, which were then at a low ebb, and to give significance once more to the work and status of the scribe. That they succeeded in this task can be seen in the vitality, variety and technical skills of penmanship today, as well as in the widespread interest in letter forms.

Rudolf von Larisch, who was sixteen years senior to Edward Johnston, was born in Verona, Italy, in 1856 and died in Vienna in 1934. He was the gifted son of an army officer and was early orphaned. For many years he was an official in the Chancery of the Austrian Emperor Franz Josef, archivist of the Order of the Toison d'Or and Keeper of the Hapsburg Records. Such appointments gave him ample opportunity for the study of historical manuscripts, in a country where long-established cultures from East and West had influenced styles of writing over the centuries. The debased penmanship of the more recent records so repelled him that he became fired with a passionate desire for handwriting reform. He published a pamphlet, *Zierschriften im Dienst der Kunst (Decorative Writing and Lettering in Art)*, and this led to his appointment as lecturer in Lettering at the Vienna School of Art in 1902 and marked the beginning of his teaching career; it was just a year after Edward Johnston had begun teaching at the Royal College of Art in London.

Rudolf von Larisch wrote numerous articles in the press in an effort to awaken the interest of the public, and he produced various portfolios with reproductions of historical examples of formal writing. His most important work, *Unterricht in Ornamentaler Schrift (A Manual of Instruction in Decorative Writing and Lettering)*, appeared in 1906 and had a notable influence in German-speaking countries. He believed calligraphy to be a natural form of creative self-expression and that penmanship therefore was of genuine educational value. He did not consider calligraphy as an end in itself, a mere exercise in virtuosity, but encouraged his students to develop their inventiveness and to carry out experiments in writing and lettering on a variety of materials, such as

wood, glass, metal, pottery and textiles, in order to discover the varying techniques and methods of expression each demanded.

This was in contrast to Johnston's teaching, which was based mainly on the study of traditional hands and on the principles arising from his researches into historical scripts. Von Larish felt that the perceptive scribe should express intuitive feeling in his work, that the pattern of the written letters on the page and the rhythm of the writing itself should harmonize, and that the whole work should express an emotional unity. He taught the proper handling and use of all kinds of writing instruments, many of which he developed by experiment, in co-operation with Rudolf Blanckertz of the well-known German firm of pen manufacturers, himself a tireless worker for calligraphy and founder of the Handwriting Museum in Berlin.

Although Rudolf von Larisch and Edward Johnston began their studies independently, and their teaching methods differed, nevertheless their aims and conclusions were sympathetically related; when they met in London in 1909 they found a mutual understanding and liking for one another. Von Larisch had a number of assistants, the best known being Dr Otto Hurm and Hertha Ramsauer, who became von Larisch's wife and carried on his work in Switzerland after his death.

Another important teacher of calligraphy in Europe was Anna Simons, who was born in 1871 and died in 1951, and came of a legal family. As women were not allowed to train in art schools in Prussia at that time, she went to London in 1896 to study at the Royal College of Art, just when the influence of the Arts and Crafts Movement was

 Anna Simons Book plate

growing, with London the centre of it. She joined Edward Johnston's class in 1901 and quickly became one of his best students. He said of her, 'She has a natural aptitude for the work and a sincerity and directness of outlook which enabled her to master the essential elements very rapidly, and later to develop them into her own practical and beautiful work.'

After obtaining her diploma at the Royal College of Art, Anna Simons returned to Germany where she began to teach Johnston's methods with enthusiasm. She was largely instrumental in bringing a new vigour to German scripts, which had lost much of their vitality. In 1905 the Prussian Ministry of Commerce arranged a lettering course for art teachers at Düsseldorf, the first of its kind, and Count Harry Kessler, already impressed by Johnston's work when they had met in London the year before, saw this as a further opportunity of introducing his teaching into Germany. Johnston himself was not available, but he recommended Anna Simons, who conducted the course with outstanding success. The Germans were already alive to the revival of fine writing, lettering and printing, and great interest was aroused by this lettering course.

It became a yearly affair and Johnston's methods were widely publicized both by Anna Simons and her pupils.

Naturally this growing interest led to a demand for a translation of Edward Johnston's manual *Writing and Illuminating, and Lettering.* This extremely difficult task was entrusted to Anna Simons in 1910. Her knowledge of English and her thorough understanding of the principles of formal penmanship, combined with her patience and conscientiousness, enabled her to carry it out with complete success. Some two years later she also translated into German the text of Johnston's portfolio, *Manuscript and Inscription Letters.*

Lettering and typographic design in Germany and Switzerland were the first to benefit from the surge of interest in craftsmanship which, stemming from William Morris and his circle, swept over Europe in the early years of the century. In Germany the movement was led by such men as Otto Echmann, Rudolf Koch, Fritz Helmuch Ehmcke, Walter Tiemann and Emil Weiss, and it had the encouragement of the art schools to support it.

At this period the Germans were moving away from their traditional Gothic hands and beginning to use roman types regularly. Stanley Morison wrote in 1926: 'The school of calligraphers practising the teaching of Johnston and Gill, which has arisen since the year 1905, has in its hands the whole of German type design, with the exception of the cruder kinds of advertising letter.' This close link between calligraphy and typography has persisted in Europe, where centres of printing are more widespread than in England and where there is a closer relationship between art schools, printing houses and the workshops of craftsmen. It is unfortunate that the same bond has not been preserved in England.

One figure who dominates the history of German calligraphy is Rudolf Koch of Offenbach, who was born in 1874 and died in 1934. He was a skilled calligrapher and type designer, and an inspiring teacher. He studied in Nuremberg, Hanau, Munich and Leipzig, at that time the most important printing centres in Germany. He worked for the Klingspor type foundry in Offenbach and taught lettering at the School of Arts and Crafts there. His students and their work were of profound importance to him and his teaching and type designing helped the development of his many talents. He re-established a close relationship between printing and penmanship and the most successful part of his creative work was his type designs. He believed that no serious calligrapher can afford to overlook the making of manuscript books, for only there will he find all the questions and only there can he prove his art in answering them. As a calligrapher Koch was at his best and most inventive in the decorative patterning of the Gothic forms of letters. He used black-letter, for example, in a vigorous, personal way that gave the writing a rich texture on the page, with closely packed lines of script, often with no interlinear spaces.

In 1918 the group of Offenbach Penmen was organized and later this developed into the Workshop Community where Koch and his assistants produced together many important works: lettering, woodcuts, weaving, embroideries, block-books printed on Japanese paper, and metal-work. These were the products of a whole group of craftsmen working together with this remarkably versatile and inspiring master

craftsman. All Koch's assistants had one thing in common, whatever their other skills might be, and that was a fundamental training in lettering. Many of his students made distinguished reputations as teachers and craft workers, among them being Henri Friedlander and Friedrich Henrichsen, both of them calligraphers; Fritz Kredel, wood-engraver and illustrator; Warren Chappell, book designer and illustrator; and Berthold Wolpe, who trained as a silversmith and is now a well-known and distinguished designer in London.

Various other workers in the field of calligraphy and related activities deserve mention here. Jan Tschichold, Hon. R.D.I., for instance, who died in 1975, exerted a considerable influence on book design in Europe and America. His obituarist in *The Times* said of him that 'he came to books and type from calligraphy, which he began to teach at the precocious age of eighteen and to which he gave a lifetime's study and affection'. Born in Leipzig early in the century, he studied at the Akademie für Graphische Kunst und Buchgewerbe in Leipzig and Dresden, and later taught lettering and typography in Munich. Among his many publications are *Geschichte der Schrift in Bildern* (published in England in 1946 as *An Illustrated History of Writing and Lettering*) and his *Meisterbuch der Schrift (Sourcebook of Writing)*, published in 1952.

Walter Kaech, who died in Zurich in 1970, acquired an international reputation as a calligrapher and taught lettering for many years. He produced comprehensive books on calligraphy, lettering and typography, among them *Schriften (Lettering)*, published in 1947, and *Rhythm and Proportion in Lettering*, which appeared in 1956.

Imre Reiner studied graphic art under Ernst Schneidler in Stuttgart and is well known for his lively calligraphic inventions and type designs. Max Caflisch was a pupil of both Jan Tschichold and Imre Reiner. He studied calligraphy and typography in Basle, where he later lectured on these subjects at the Allegemeine Gewerbeschule.

Hermann Zapf, who was born in 1918, enjoys a world-wide reputation as a typographer, letter designer and calligrapher. He has taught lettering and book design in Germany and lectured widely in Sweden and America. He was self-taught and was influenced by the books of Edward Johnston and Rudolf Koch. His well-known book *Feder und Stichel (Pen and Graver)* contains many splendid examples of his calligraphy and lettering engraved by August Rosenberger.

In Czechoslovakia the art of lettering has been associated with one outstanding personality: Oldřich Menhart of Prague, who was born in 1897 and died in 1962. He was descended from a line of craftsmen and his early training made him a master of pen and graver. As a book artist he successfully combined calligraphy, lettering, typography and type design. He absorbed the heritage of western scripts and disciplined his hand by arduous practice. His penmanship is vigorous and his letter forms are ruggedly strong. He held that a good type cannot be designed until it has been written, and the pen has been the inspiration of many of his own type designs. One of Menhart's most remarkable works was the transcription of *Kytice*, a Czech classic, as a manuscript of some 150 pages; it was illustrated by Antonin Prochazka and the whole was reproduced in facsimile. The lettering Menhart used for this book subsequently became his Manuscript type, in both roman and italic forms. He said of his Uncial type, which appeared in 1949, that it was the result of twenty-six years of study.

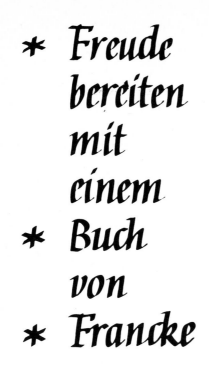

Oldřich Menhart Book plate

Max Caflisch Advertisement for a publisher

Jan van Krimpen designed some of the most notable type-faces of this century and as a type designer, calligrapher and book artist he is one of the great masters. His italic types were based on Renaissance scripts, which he also used as the basis of his own handwriting. The success of his printing types, chiefly designed for the firm of Joh. Enschedé en Zonen, brought him requests for lettering of many kinds—written, painted and engraved. He transcribed a number of manuscripts on vellum for his own pleasure and his formal calligraphy included work presented to royalty. The Dutch were fortunate in having a far-sighted craftsman with the skill and wide vision that Jan van Krimpen brought to the design of printing type at the very time when the traditional Gothic forms were being displaced by roman and italic founts.

In association with Bruce Engelhart, Chris Brand, also a calligrapher and typographer, has done a great deal to encourage fine handwriting in the Netherlands, particularly with the production of a series of delightful booklets, *Ritmisch Schrijven (Writing Rhythmically)*, as a writing method for primary schools.

Gerrit Noordzij of the Netherlands, when asked for the loan of work to appear in this book, sent an original collection of 'trial-and-error' pages of writing. He explains: 'Handwriting is my most important source of type design and typography. These trials should give an impression of this process. I allow myself absolute freedom, be-

cause such writing has no other purpose than my own flexibility.' His contribution to *Dossier A–Z 73* was particularly thought-provoking on the subject of teaching letter forms. This *Dossier* was the fruit of the Congress held in 1973 by the Association Typographique Internationale. It contained contributions by calligraphers, typographers and graphic designers, all of whom had expert opinions to express.

Another valuable contribution to the literature of calligraphy is the historical survey *ABC of Lettering and Printing Types* (in three parts) by Erik Lindegren of Sweden, which gives short biographies of contemporary graphic designers and illustrates examples of their lettering, calligraphy and type designs.

In Denmark Bent Rohde, with his book *Bredpenkursiv (Broad Pen Cursive)*, has influenced many students towards good letter forms. He has also translated and transcribed into Danish Arrighi's *La Operina*, and his own work deserves special attention for the beauty of his italic scripts.

The outstanding work of Villu Toots illustrated in this edition is of special interest as an example of lettering from one of the Soviet Socialist Republics. Toots explains that Estonia—whose language is very different from Russian—has an entirely independent cultural life, although of course it has felt the intellectual influence of immediate neighbours, such as the Germans and Scandinavians as well as the Russians. Born in Estonia in 1916, Villu Toots trained as a graphic designer, and this led to his work as art director of a Tallinn publishing house. He is now a freelance book artist but also teaches at the Lettering Art School which he founded in 1965 for students, artists and teachers. He is currently head of the book artists' branch of the Estonian League of Artists and is responsible for lettering exhibitions and symposia. His *Eesti Kirjakunst 1940–1970* is a vigorous and colourful work on Estonian lettering art. Unfortunately his books are not easily available in the West, nor are they translated.

Friedrich Poppl, born in 1923, after his art training became a Member of the Arts and Crafts School at Weisbaden and subsequently Professor at the Technical College there. He specializes in designing alphabets for typesetting and photoprinting, extending the frontiers of calligraphic influence further than ever before. Like many European designers he holds that 'Calligraphy will always remain the starting point for script design.' The examples of his work illustrated here show a superb sense of spacing, and his more exuberant styles, which he defines as 'outside the norm in calligraphy', have a refreshing vitality.

In the graphic arts there is a continuing European tradition of accomplishment in every field—that is to say, in calligraphy, lettering, type design, book design and illustration. Lettering thus attracts artistic talents and becomes itself an art form, as we see from the output of Poppl, Hoefer, Neugebauer, Waibel and Toots, and from others whose work is illustrated in this book. These are highly skilled letterers, experimenting with the pattern and expression of words, using words as semi-abstract shapes to communicate with letters in unconventional and intuitive ways. Letters are thought of as a medium: their colour, form, texture and pattern are integral parts of the whole, which may become an exhilarating work of abstract art in the hands of imaginative craftsmen.

Calligraphy in the United States

It is not surprising that in a country as vast as the U.S.A., the growth of interest in calligraphy this century has tended to emerge and flourish around the teaching and influence of distinguished individual calligraphers in local centres as far apart as New York, Rhode Island, Boston, Chicago, Portland, Oregon, and more recently in California.

Early attempts to reform handwriting, lettering and type design were made by men such as Frederic W. Goudy (1865–1945), Bruce Rogers (1870–1957), and William A. Dwiggins (1880–1956). But strong, less beneficial influences—the Spencerian script copy-books and the Palmer method of business writing—held penmanship in their mechanical and mannered grip well into the twentieth century.

William Addison Dwiggins had a wide-ranging talent for lettering, illustration and type design that was unique in the graphic arts of America. As early as 1907 he had suggested to Goudy that they should form a calligraphic society, but in vain. In 1925, however, he formed a purely imaginary 'Society of Calligraphers' and issued handsome certificates of honorary membership to twenty-two people in the field of publishing

W. A. Dwiggins Chapter heading

and the graphic arts. As a calligrapher he generally used both a formal and a semi-formal hand, at first in advertising and then in book production. His work for type design was outstanding and for thirty years he designed books for Alfred A. Knopf, the New York publishers. His calligraphy owes little to European sources and has a gaiety and originality entirely its own. Philip Hofer, curator of the Printing and Graphic Arts Department in Harvard College Library, said in 1935 that the revival of interest in the art of calligraphy was in large measure due to Dwiggins: 'In it he stands head and shoulders above any other American designer—as individual in his style as he is accomplished and imaginative.'

One of the earliest exponents of formal writing was Ernst Frederick Detterer of Chicago. He came to England in 1913 and for a short time had private lessons from Edward Johnston. He played an important part in the development of the calligraphic tradition, particularly in the Mid-West, by his teaching and practice of the craft, and he encouraged such distinguished scribes as James Hayes and Raymond DaBoll to broaden and extend their use of calligraphy. In 1931 Detterer became curator of the John M. Wing Foundation of the Newberry Library in Chicago, which holds an outstanding collection of calligraphic material, including works by early European writing masters.

Using as a focus the material in the Library's collection, Detterer founded the Newberry Library Calligraphy Study Group, which became a potent influence in the development of American calligraphy. Many of today's practitioners can trace their inspiration to this source. It was carried on after Detterer's death by James Hayes and James M. Wells, who himself became curator of the Wing Foundation in 1951.

Another important American calligrapher was John Howard Benson, who lived and worked in Newport, Rhode Island, where he was born in 1901 and died in 1956. Johnston's manual inspired in Benson so strong a desire to create beautiful letters that his whole life became directed to that end. He studied in New York at the National Academy of Design and at the Art Students League at a time when lettering had no recognized place in art education. A versatile and genuine craftsman, he was also attracted by typography, but a happy chance changed the direction of his work and he turned to cutting letters of beauty and distinction in stone; this tradition has been carried on by his son John E. Benson who is himself a fine letter cutter. In 1950, together with his partner Graham Carey, John Howard Benson published the outcome of his experience in teaching and practising calligraphy in the form of a manual for students, entitled *Elements of Lettering*. He came into possession of an Arrighi manual of 1554, *La Operina*, and having mastered the italic hand himself, proceeded to translate it into English and then transcribed his version for facsimile publication in 1954. It was an immediate success, bringing him many friends towards the end of his life.

Edward Karr, born in Connecticut in 1909, has also been influential as an instructor of calligraphy and lettering. He has taught at the School of the Museum of Fine Arts in Boston for many years.

Arnold Bank, another influential calligrapher and teacher, was born in New York in 1908. He trained there and has taught in many of the principal schools in the New York area. As a Fulbright Senior Fellow Lecturer in the Lettering Arts he is re-membered for his inspiring teaching and his dynamic lettering demonstrations in England between 1954 and 1957. His own work is adventurous and full of vigour, colour and excitement.

Interest in the revival of italic handwriting in America began in the first quarter of this century. Ernst Detterer was already teaching italic in 1924. In the same year Marjorie Wise, a teacher, published *The Technique of Manuscript Writing*, which sold many thousands of copies over a period of two decades. And Frederic Warde contributed to the revival by bringing out, in 1926, a facsimile edition of Arrighi's two writing manuals.

Credit is also due in this respect to Paul Standard, born in New York in 1896, who is now widely known as a calligrapher, teacher and writer. He has long campaigned for a reform of handwriting in American schools based on Arrighi's italic hand and English exemplars derived from that style, and he has converted a number of private schools to the adoption of italic. For many years he taught at the Cooper Union Art School in New York. His book *Calligraphy's Flowering, Decay and Restoration* was published in 1947.

In the North-West the fine teaching of Professor Lloyd Reynolds, recently designated Calligrapher Laureate of Oregon, has been pre-eminent. After a brief period in the commercial field Lloyd Reynolds joined the Reed College faculty in 1929. Here, like many others, he was greatly influenced by Johnston's manual, and with the help of Alfred Fairbank and Arnold Bank he became a calligrapher. He has always stressed the beauty and versatility of italic and it is due mainly to his energy and drive that Portland, Oregon, has become one of the most important and well-known calligraphic centres. The list of his students who have become professional scribes is impressive. Among his publications is *Italic Calligraphy and Handwriting*, of 1969.

In 1958 Lloyd Reynolds mounted an exhibition at the Portland Art Museum and gave it the title 'Calligraphy: The Golden Age and Its Modern Revival'. It was the culmination of his years of research and study into the historic styles of writing, and the work that was shown ranged from the time of Charlemagne to the present day. The exhibition demonstrated his conviction that the tradition which produced such work is still a living force, underlying the modern revival of calligraphy. Exhibitions of calligraphy have played an influential part in the movement in America, as the excellent illustrated catalogues—an extension of the exhibitions themselves—faithfully remind us. In 1959 P. W. Filby mounted an exhibition of 'Calligraphy and Illumination' at the Peabody Institute Library, Baltimore, of which he was the Assistant Director at the time. Much of the material shown was the work of English calligraphers, most of them members of the Society of Scribes and Illuminators. This exhibition was followed in 1961 by another at the Peabody Institute, 'Calligraphy and Handwriting in America, 1710–1961', which showed some of the history of the art, together with the work of many American scribes from the time of Dwiggins and Detterer. These exhibitions were forerunners to the magnificent tripartite showing in 1965, 'Two Thousand Years of Calligraphy', organized by Dorothy Miner, Keeper of Manuscripts at the Walters Art Gallery, Baltimore; Victor Carlson, Curator of Prints and Drawings at the Baltimore Museum of Art; and P. W. Filby, Assistant Director of the Peabody Institute Library. The exhibition illustrated the long historic background of calligraphy and traced the various developments through the centuries to our own, including some of the best work being done by scribes today. The scholarly commentaries to the three sections, the short biographical details about the many contemporary calligraphers, and an illustration of almost every exhibit, make the catalogue of this exhibition a valuable reference book.

American scribes use the formal and semi-formal italic hands extensively in designing book jackets, titles, advertisements, certificates and similar work in the graphic design field. This popular hand is demonstrated at almost every calligraphic course, and it is

Rick Cusick Personal device for the
calligrapher Egdon Margo

also a model, taken from various sources, for teaching everyday handwriting. For many years Paul Standard applied the italic hand successfully to his commissions; Ray DaBoll has for long used many variations of it in commercial art; Maury Nemoy's simple applications of it are always appropriate; the italic hands of Egdon Margo, James Hayes and Rick Cusick are visually satisfying and very readable; and there are many other well-known exponents of the style in America today.

Schools in America have been slow to adopt the italic style of cursive writing. The many books produced by Fred Eager, however, are of great service to this end. *The Italic Way to Beautiful Handwriting*, for instance, published in 1974, is a revision and expansion of his previous *Guide to Italic Handwriting*. It has an instructive foreword by Sheila Waters and is designed as a complete teaching course for both children and adults.

Sheila Waters, the only Craft Member of the Society of Scribes and Illuminators resident in the U.S.A., holds calligraphic workshop seminars in Bethesda, Maryland. Her teaching of calligraphy, and the workshop courses held in various centres in America by Donald Jackson, a visiting member of the S.S.I., have further encouraged the development of formal penmanship based on the historical approach to letter forms.

Although the strongest influence on American writing masters is italic, it is of particular satisfaction to a British author to note also the upsurge of interest in formal calligraphy in the past few years in the United States. Societies have been founded and are flourishing at a number of local centres; and small exhibitions, classes, lectures and periodicals also testify to this increased awareness.

It has been fashionable in some quarters to deride the historical approach to letter forms that was advocated by Edward Johnston and is currently characteristic of calligraphic training in Britain. Pupils often need to oppose accepted teaching in their search for personal truth, and too rigid an adherence to Johnston's precepts has perhaps been inhibiting to some of his followers. In *Formal Penmanship* Johnston clearly makes the point that liberation comes by understanding the laws inevitably dictated by the tools of the craft. With this knowledge rules may be treated as springboards; they have to be understood thoroughly before one can be sure that one is breaking them in the right spirit.

It was well said (in *The Times Literary Supplement* in 1965) that

'The art of calligraphy has been twice killed stone dead by a mechanical invention and has twice found a new set of justifications. As an industry for the manual copying of texts it was destroyed by the printing press. As an essential tool of commerce and finance, and an evidence of gentility, it flourished for three centuries and was strangled

by the typewriter. In its third and present lifetime it stands with the fine arts, safe from any further technological threat.'

There is clear evidence today that scribes on both sides of the Atlantic are approaching calligraphy as an art and using the wide range of tools and materials now available with imagination, bringing fresh life into the design of letter forms and the written page.

In America, as in Britain, there are fortunately still patrons with knowledge and perception who collect and commission new works, whether as a form of fine art or as graphic art. Considered as a work of fine art, an example of calligraphy will be judged as we would judge a drawing or a painting—for its inner life or its outward appearance (which includes that unfashionable concept, its decorative quality). In assessing a work of calligraphy from a graphic point of view, it is worth bearing in mind Stanley Morison's foreword to *The Work of Jan van Krimpen*, in which he wrote:

'The history of calligraphy and typography is mainly a matter of tracing variations caused by cultural, linguistic, nationalistic and economic factors. The basic principle remains that the function of these arts is to communicate, and will remain, in spite of all variations due to these factors, or to the predilections of any individual scribe or typographical designer.'

The heart of the matter is *quality*. Just as we judge the writing of the past by our own criteria of excellence, so will the work of our time be judged by future eyes. It is not important that the work may be ephemeral in our terms: in projects such as book jackets or advertisements the quality of the writing can still attain a superlative excellence. When a scribe has the good fortune to land a commission for a calligraphic work of some substance and even grandeur, it is even more obvious that it should be made to endure and should be as fine as he can make it. The ideal, in any case, should be always to write with such vitality that even the least important line of script can evoke the words of Robert Bridges:

> I too will something make,
> And joy in the making.

The Scribe

The present Scribe introduced
the seven Larger Capitals in lines
9, 17, 21, & 26. And wrote the
Emphasized Script, the Book not
indicating otherwise the breathing
it over the page between 11, 16, & 17.

What lovely things
Thy hand hath made:
The smooth-plumed bird
In its emerald shade,
The seed of the grass,
The speck of stone
Which the wayfaring ant
Stirs — and hastes on!

Though I should sit
By some tarn in thy hills,
Using its ink
As the spirit wills
To write of Earth's wonders,
Its live, willed things,
Flit would the ages
On soundless wings
Ere unto Z
My pen drew nigh:
Leviathan told,
And the honey-fly:
And still would remain
My wit to try —
My worn reeds broken,
The dark tarn dry,
All words forgotten —
Thou, Lord, and I.

Edward Johnston 'The Scribe' by Walter de la Mare. Transcribed in the Foundational Hand on vellum for Miss D. L. Bishop (Dorothy Mahoney), 1929

45

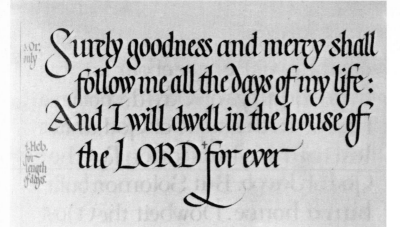

Surely goodness and mercy shall follow me all the days of my life: And I will dwell in the house of the LORD for ever

Edward Johnston From his *Book of Sample Scripts*: the last four lines of Psalm Twenty-three, written in a formal italic hand which he developed, together with the Foundational Hand, from his study of tenth-century manuscripts, especially the Ramsey Psalter (British Museum Harley MS. 2904). Size 22·9 × 17·8 cm. 9 × 7 in. Victoria and Albert Museum (L 4391 1959)

Edward Johnston Extract from Plato's *Symposium*, written in black on vellum, the three Greek words in Uncials, the six-line quotation in a sharpened italic and the gloss in a semi-formal hand. Johnston considered this one of his best manuscripts. It was given to Alfred Fairbank by the Society of Scribes and Illuminators in 1934

ΥΠΑΡΧΕΙΘΕΟΦΙΛΕΙΓΕΝΕCΘΑΙ

"...in that communion only, beholding beauty with the eye of the mind, he will be enabled to bring forth, not images of beauty, but realities (for he has hold not of an image but of a reality) and bringing forth and nourishing true virtue to become the friend of God and be immortal, if mortal man may."

GESCHICHTE DER SCHRIFT

KAROLINGERSCHRIFT·IX·JAHRHUNDERT

CUI NOMEN ERAT JOHANNES. HIC UENIT
in testimonium perhiberet de lumine·ut omnes
crederunt per illum·Non erat ille lux sed ut testi-
monium perhiberet de lumine·Erat lux uera:

GOTISCHE SCHRIFT·XIII·JAHRHUNDERT

Ouch erkande ich nie so wisen man, Swer mit disen schanzen allen kan
Ern möhte gerne künde han, An dem hat witze wol getan,
Welher sture disiu mære gerut Der sich niht versitzet noch verget
Vud waz si guoter lere werut. Vnd sich anders wol verstet.

ANTIQUA MINUSKEL·XV·JAHRHUNDERT

None ancor giusta assai cagion dichiolo che inhabito il
ruidi chio ne piansi si tolte glieran lali elgire auoli on
con altro furor dipecto dansi due leon feri o due fulgon

SCHWABACHERSCHRIFT·XVI·JAHRHUNDERT

Weil jhr aber so grosse Bitt Gantz quitledig all seiner band
Anlegt, wöll wir ihn richten nicht Jedoch soll er raumen das land
Sonder zu ehren euch gemein Vnd nimmermehr kommen darein
Sol jhm das Leben gschencket sein Zu straff dieser verhandlung sein.

FRAKTUR SCHRIFT·MITTE·DES·XVI·JAHRHUNDERT

Zum ersten mach ein rechte firung von gleichen seyten vnd wincklen
vnd teyll die mit vier par linie aufrecht vnnd oberztwerch/in neun
kleyn firung/vnd setz in ytliche ein mittel puncten vnd nimm ein
cirkel setz in mit dem ein fuß in die selben puncten nach ein ander,

Anna Simons A specimen page from
Die Geschichte der Schrift, a portfolio of
examples of formal penmanship from the
9th to 16th century. Published by Verlag
Heintze & Blanckertz, about 1930

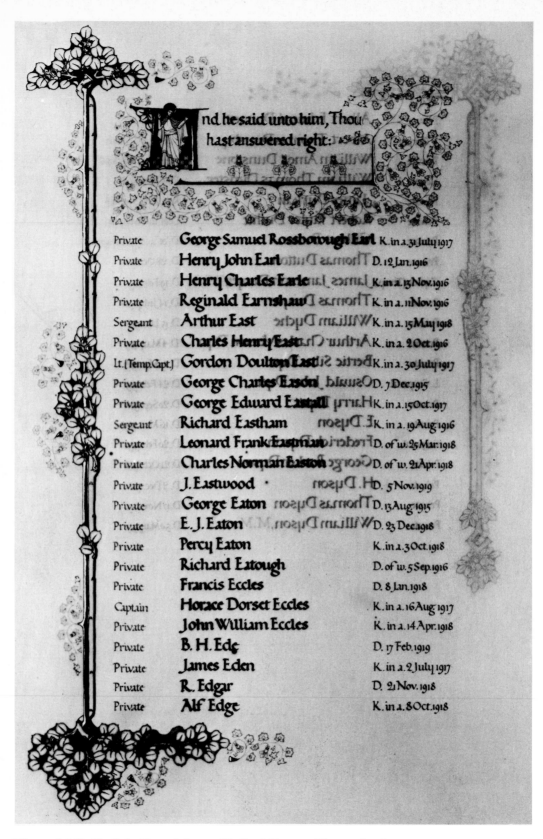

And he said unto him, Thou hast answered right:

Private	George Samuel Rossborough Earl	K. in a. 31 July 1917
Private	Henry John Earl	D. 12 Jan. 1916
Private	Henry Charles Earle	K. in a. 13 Nov. 1916
Private	Reginald Earnshaw	K. in a. 11 Nov. 1916
Sergeant	Arthur East	K. in a. 15 May 1918
Private	Charles Henry East	K. in a. 2 Oct. 1916
Lt. [Temp.Capt.]	Gordon Doulton East	K. in a. 30 July 1917
Private	George Charles Easton	D. 7 Dec. 1915
Private	George Edward Eastall	K. in a. 15 Oct. 1917
Sergeant	Richard Eastham	K. in a. 19 Aug. 1916
Private	Leonard Frank Eastman	D. of w. 25 Mar. 1918
Private	Charles Norman Easton	D. of w. 21 Apr. 1918
Private	J. Eastwood	D. 5 Nov. 1919
Private	George Eaton	D. 13 Aug. 1915
Private	E. J. Eaton	D. 23 Dec. 1918
Private	Percy Eaton	K. in a. 3 Oct. 1918
Private	Richard Eatough	D. of w. 5 Sep. 1916
Private	Francis Eccles	D. 8 Jan. 1918
Captain	Horace Dorset Eccles	K. in a. 16 Aug. 1917
Private	John William Eccles	K. in a. 14 Apr. 1918
Private	B. H. Edc	D. 17 Feb. 1919
Private	James Eden	K. in a. 2 July 1917
Private	R. Edgar	D. 21 Nov. 1918
Private	Alf Edge	K. in a. 8 Oct. 1918

Memorial Roll of the Royal Army Medical Corps The work of
Graily Hewitt and his assistants Horace Higgins, Madelyn Walker,
Florence Raymond, Ida Henstock, Vera Peacock and Reco Capey.
The writing, in a 15th-century Italian style, is mainly the work of
Horace Higgins. In the Chapter House, Westminster Abbey.
Courtesy of the Director General, Army Medical Services

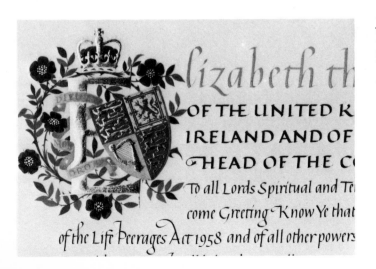

H ic haedos depone, tamen veniemus in urbem.
A ut si, nox pluviam ne colligat ante, veremur,
C antantes licet usque – minus via laedit – eamus;
C antantes ut eamus, ego hoc te fasce levabo.
M.Desine plura, puer, et quod nunc instat agamus;
C armina tum melius, cum venerit ipse, canemus.

GALLVS · ECLOGA DECIMA

X HVNC, ARETHVSA, MIHI CON
T CEDE LABOREM: PAVCA MEO
R GALLO, SED QVAE LEGAT IPSA
E LYCORIS, CARMINA SVNT DI
M CENDA: NEGET QVIS CARMINA
V GALLO? SIC TIBI, CVM FLV
M CTVS SVBTERLABERE SICANOS

D oris amara suam non intermisceat undam,
I ncipe; sollicitos Galli dicamus amores,
D um tenera attondent simae virgulta capellae.
N on canimus surdis, respondent omnia silvae.
Q VAE nemora aut qui vos saltus habuere, puellae
Naides, indigno cum Gallus amore peribat?
N am neq; Parnasi vobis iuga, nam neq; Pindi
V Illa moram fecere, neque Aonie Aganippe.
I llum etiam lauri, etiam flevere myricae,
P inifer illum etiam sola sub rupe iacentem

M aenalus, et gelidi fleverunt saxa Lycaei.
S tant et oves circum – nostri nec paenitet illas,
N ec te paeniteat pecoris, divine poeta:
E t formosus ovis ad flumina pavit Adonis –
V enit et upilio, tardi venere subulci,
V vidus hiberna venit de glande Menalcas.
O mnes unde amor iste rogant tibi? Venit Apollo:
G alle, quid insanis? inquit. Tua cura Lycoris
P erque nives alium perque horrida castra secuta est.
V enit, et agresti capitis Silvanus honore,
F lorentis ferulas et grandia lilia quassans.
P an deus Arcadiae venit, quem vidimus ipsi
S anguineis ebuli bacis minioque rubentem.
E equis erit modus? inquit. Amor non talia curat:
N ec lacrimis crudelis Amor nec gramina rivis
N ec cytiso saturantur apes nec fronde capellae.
T ristis at ille tamen cantabitis, Arcades inquit,
M ontibus haec vestris, soli cantare periti
A rcades. O mihi tum quam molliter ossa quiescant,
V estra meos olim si fistula dicat amores
A tque utinam ex vobis unus vestrique fuissem
A ut custos gregis aut maturae vinitor uvae!
C erte sive mihi Phyllis sive esset Amyntas
S eu quicumque furor – quid tum, si fuscus Amyntas?
E t nigrae violae sunt et vaccinia nigra –
M ecum inter salices lenta sub vite iaceret;
S erta mihi Phyllis legeret, cantaret Amyntas.

Alfred Fairbank Virgil: *Eclogues and Georgics*. Writing and gilding by Alfred Fairbank, illuminating by Louise Powell, 1932–9. Size 30·5 × 20·3 cm. 12 × 8 in. Courtesy of Simon Hornby Esq.

Joan Pilsbury Illuminated initial from a Patent of Nobility, 1975. The Sovereign's name is in blue, the 'E' in raised and burnished gold, the Royal Arms in full colour, with red roses

Schaff das Tagwerk meiner Hände / hohes Glück, daß ichs vollende · Laß, o laß mich nicht ermatten · Nein / es sind nicht leere Träume · Jetzt nur Stangen / diese Bäume geben einst noch Frucht und Schatten ·

Bild 21

Rudolf Koch Illustration from *Das Schreibbüchlein*, an introduction to writing with woodcuts by Fritz Kredel, 1935. The pattern of the writing has been carefully considered as a whole. Decorative elements have been used as space filling devices. Size 17·8 × 14 cm. 7 × 5½ in.

Rudolf Koch A Gothic hand more freely written than in the illustration above but from the same source

Schaffe in mir Gott ein reines Herze, und gib mir einen neuen, gewissen Geist. Verwirf mich nicht von deinem Angesicht und nimm deinen heiligen Geist nicht von mir·

Rudolf Koch The decorative quality of black-letter is shown in this example written in 1933

Ist Gott für uns, wer mag wider uns sein? Welcher auch seines eigenen Sohnes nicht hat verschonet, sondern hat ihn für uns alle dahin gegeben, wie sollte er uns mit ihm nicht alles schenken? Wer will die Auserwählten Gottes beschuldigen? Gott ist hier, der da gerecht macht, wer will verdammen? Christus ist hier, der gestorben ist, ja viel mehr, der auch auferwecket ist, welcher ist zur Rechten Gottes und vertritt uns·

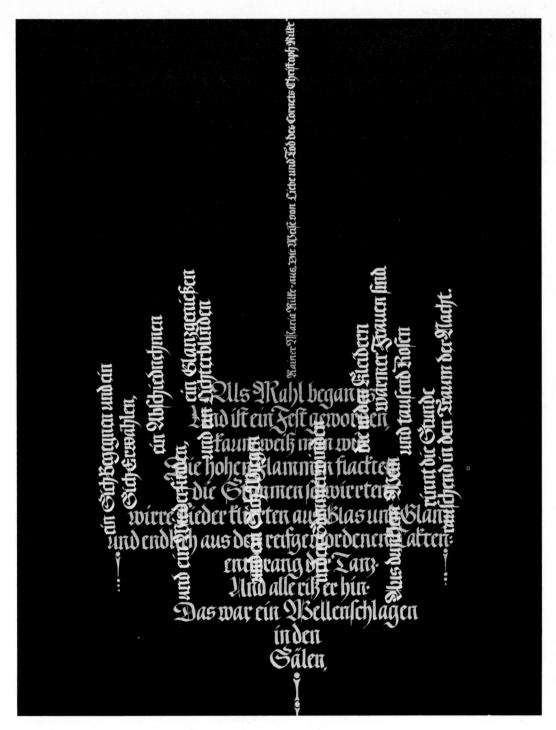

Hella Basu 'Als Mahl Beganns' by Rainer Maria Rilke. Written in
fraktur style with a broad steel nib in gold and white gouache on
black paper. The lay-out resembles a candelabrum, evocative of the
glittering lights of the ballroom in the poem

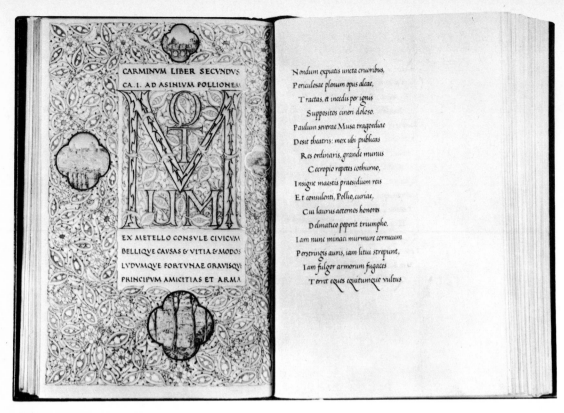

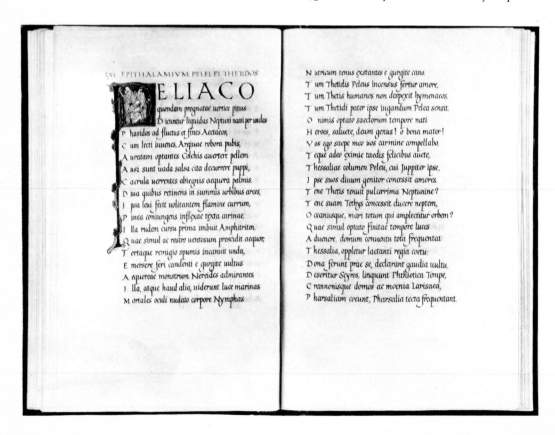

GⱽRI

Graily Hewitt Scroll sent from H.M. King George V to relatives of the fallen after the First World War. Engraved by Noel Rooke and reproduced in black with the capital letter in red and the arms in colour. Size 27·9 × 18·4 cm. 11 × 7¼ in.

HE whom this scroll commemorates was numbered among those who, at the call of King and Country, left all that was dear to them, endured hardness, faced danger, and finally passed out of the sight of men by the path of duty and self-sacrifice, giving up their own lives that others might live in freedom.
Let those who come after see to it that his name be not forgotten.

Rudolf von Larisch A tribute to Anna Simons, in the form of a certificate, in gratitude for her work as a teacher, artist and pioneer

FRAU PROFESSOR
ANNA SIMONS
die erfolgreiche Gestalterin in der Buch- und Schreib,
kunst hat nicht nur zahlreiche künstlerische Arbeiten
geschaffen, sie hat auch durch ihr langjähriges päda,
gogisches Wirken auf dem Gebiete der Schriftgestal,
tung neue Jünger und Anhänger gewonnen. Ich
freue mich, als ihr Kollege und Mitstrebender dieser
hervorragenden Leistungen und bringe ihr aus die,
sem Anlasse meine herzlichsten Glückwünsche und
Grüße in alter Freundschaft und Ergebenheit.

Wien, im Nov. 1932 *Prof. Rudolf von Larisch*

53

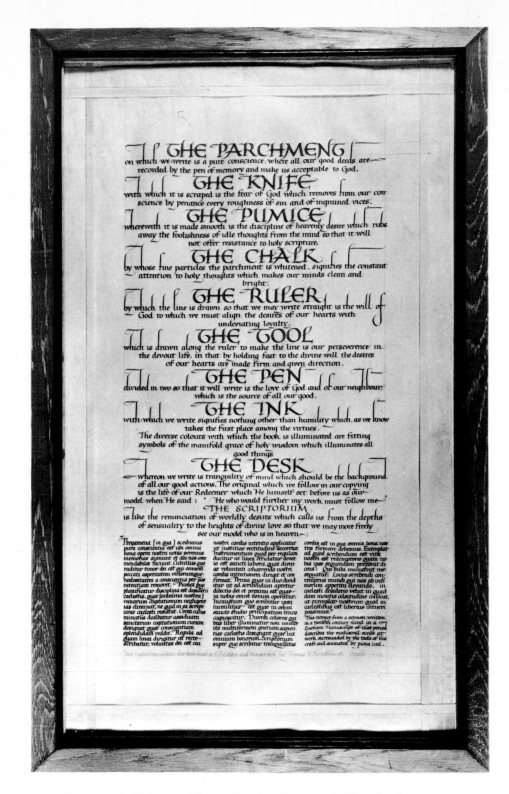

T. W. Swindlehurst The medieval scribe at work. Translated
from a sermon, written in a twelfth-century hand (copied at the foot of
the page) from a Durham manuscript of that period, describing the
medieval scribe surrounded by the tools of his craft and animated by
pious zeal. Note that the vellum leaf is itself bound with strips of vellum

above
Dorothy Mahoney Calligraphic map, 1968. From the Book Recording Memorial Gifts made to St Felix School, Southwold, since its inception

below
Margaret Alexander Presentation address written on vellum in black, red, blue and gold, 1963. Size 35·6 × 24·1 cm. 14 × 9½ in.

UNIVERSITY COLLEGE LONDON

AT THEIR MEETING ON 11 JUNE 1963 THE PROFESSORIAL BOARD RESOLVED "That on the occasion of

DR MARGARET MURRAY'S

100 TH

BIRTHDAY, 13 JULY 1963,

they wish to place on record their deep appreciation of the high honour which, through her renowned scholarship, she has brought to University College London, where she taught for so many years. Trained in her early Egyptological study by Sir Flinders Petrie, Dr Murray became his "right hand", & in relieving him of a great part of his teaching work in the College, she made possible the vast output of his work in the field; Sir Flinders Petrie was always first in acknowledging his debt to her. And there were others: scholars of international repute such as Wainwright, Brunton, Englebach, Starkey, Lankaster Harding & Faulkner, who owed their early training at the College to Dr Murray.

IN her own research, she was just as successful as in her teaching. Books & articles, both scientific & popular, have come from her pen not only on Egyptology but in many other fields, such as her latest book, The Genesis of Religion, published in this year, the hundredth of her long life. In addition to this, Dr Murray's excavations at the Osireion at Abydos, & her epigraphic work in the necropolis at Sakkara are recognised as monumental contributions to Egyptological research.

THE Professorial Board desires to express to Dr Murray its thanks for all she has done for the College, not only during the long period of her service on its academic staff but also for her valuable association with its Department of Egyptology, in which her interest still continues long after her official retirement."

Berthold Wolpe Book jackets for Faber and Faber, London

aacejgiiiigq
firiiittrvkpt
ffie&"„;ll!?¢§

Plate 5. Reed-written roman minuscules, alternates, and punctuation.

ABCDEFGHIJ
KLMNOPQRT
SUVWXY&Z

Plate 7. Semi-formal majuscules.

Edward M. Catich From his portfolio of *Reed, Pen and Brush*
Alphabets for Writing and Lettering, published by The Catfish Press, Iowa, 1972

above
Dorothy Hutton 'The Quiet Mind'.
One of three poems in a manuscript book
written on vellum and decorated with colour
throughout

right
Margaret Alexander Thirteenth-century
lyric from the Benedictbeuern MS.,
translated by Helen Waddell, transcribed
and illuminated on vellum

below
Marie Angel Illuminated initials on a
vellum leaf, made for Heather Child.
Size 10·2 × 10·2 cm. 4 × 4 in.

O SPRING
THE LONG-DESIRED,
The lover's hour!
O flaming torch of joy,
Sap of each flower,
All hail!
O jocund company
Of many flowers,
O many-coloured light,
All hail!
And foster our delight!
The birds sing out in chorus.
O youth, joy is before us,
Cold winter has passed on,
And the Spring winds are come!

The earth's aflame again
With flowers bright,
The fields are green again,
The shadows deep,
Woods are in leaf again,
There is no living thing
That is not gay again,
With face of light
Garbed with delight.
Love is reborn,
And Beauty wakes from sleep.

58

the dream of the rood

HWÆT

a dream came to me
at deep midnight
when humankind
kept their beds
· the dream of dreams.
I shall declare it.

it seemed i saw the tree itself
borne on the air, light wound about it,
~a beam of brightest wood, a beacon clad
in overlapping gold, glancing gems
fair at its foot, and five stones
set in a crux flashed from the crosstree.
around angels of god
all gazed upon it,
since first fashioning fair.
it was not a felon's gallows,
for holy ghosts beheld it there,
and men on mould, and the whole making
shone for it
~signum of victory! stained and marred,
stricken with shame, i saw the glory-tree
shine out gaily, sheathed in yellow
decorous gold; and gemstones made
for their maker's tree a right mail-coat.
yet through the masking gold i might perceive
what terrible sufferings were once
sustained thereon:
it bled from the right side. ruth in the heart.
afraid i saw that unstill brightness
change raiment and colour
~again clad in gold
or again slicked with sweat.
spangled with spilling blood.
yet lying there a long while
i beheld, sorrowing, the healer's tree
till it seemed that i heard how it
broke silence.
best of wood, and began to speak:
over that long remove my mind ranges
back to the holt where i was hewn down:
from my own stem i was struck away,
dragged off by strong enemies,
wrought into a roadside scaffold.
they made me a hoist for wrongdoers.
the soldiers on their shoulders bore me.
until on a hill-top they set me up;
many enemies made me fast there.
then i saw, marching toward me,
mankind's brave king;
he came to climb upon me.
i dared not break or bend aside

Leslie Benenson Manuscript page from the Anglo Saxon poem 'The Dream of the Rood'. Written in red Uncials on vellum, with the runes and decorative elements in gold, blues and greens. Page size 43·2 × 25·4 cm. 17 × 10 in. Presented to Heather Child by the S.S.I. in 1971

Villu Toots Title for a diploma, 1972

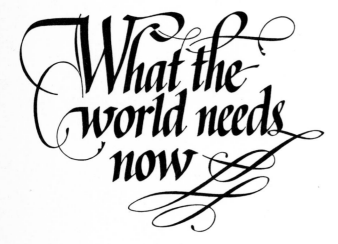

Edward A. Karr Heading of a full-page newspaper advertisement

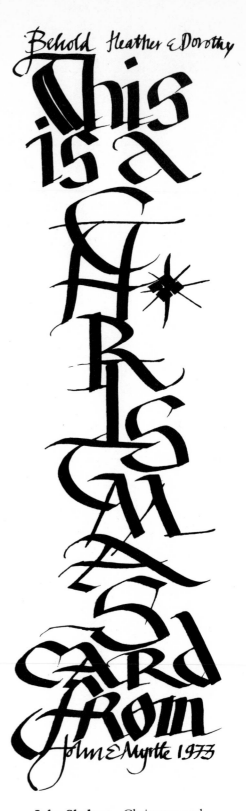

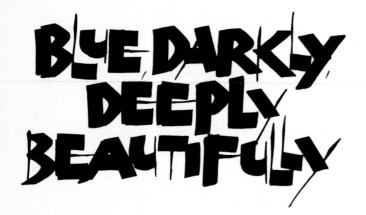

David Howells The manuscript was written in various intense blues

John Skelton Christmas card

Merry-go-Round

above
John Woodcock BBC TV credit card

left
Heather Child Word written with a reed pen

below
Villu Toots Book jacket, 1972

CALLIGRAPHY

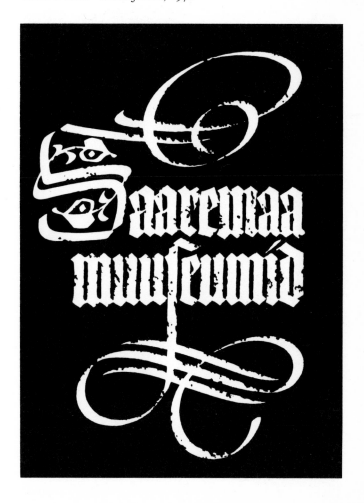

Saaremaa
muuseumid

61

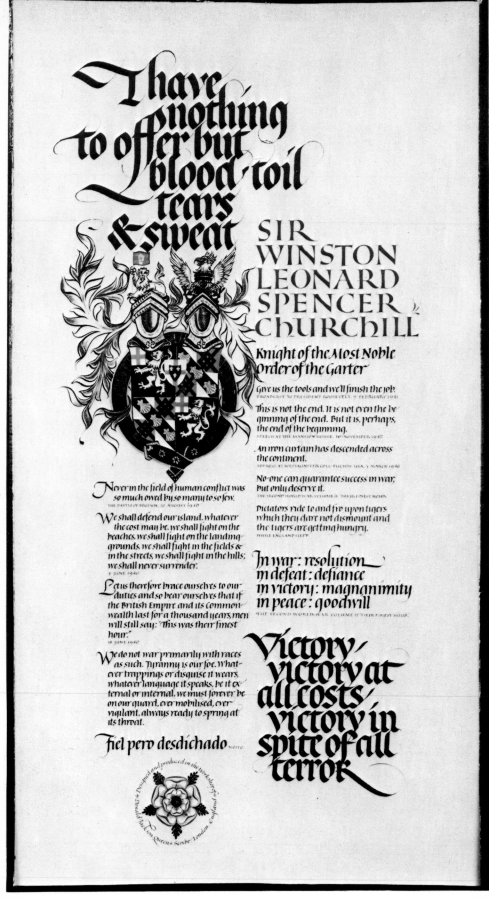

I have nothing to offer but blood toil tears & sweat

SIR WINSTON LEONARD SPENCER CHURCHILL

Knight of the Most Noble Order of the Garter

Give us the tools and we'll finish the job.
BROADCAST TO PRESIDENT ROOSEVELT, 9 FEBRUARY 1941

This is not the end. It is not even the beginning of the end. But it is, perhaps, the end of the beginning.
SPEECH AT THE MANSION HOUSE, 10 NOVEMBER 1942

An iron curtain has descended across the continent.
ADDRESS AT WESTMINSTER COLL. FULTON. USA, 5 MARCH 1946

No one can guarantee success in war, but only deserve it.
THE SECOND WORLD WAR, VOLUME II: THEIR FINEST HOUR.

Dictators ride to and fro upon tigers which they dare not dismount and the tigers are getting hungry.
WHILE ENGLAND SLEPT

In war: resolution
in defeat: defiance
in victory: magnanimity
in peace: goodwill
THE SECOND WORLD WAR VOLUME II: THEIR FINEST HOUR.

Never in the field of human conflict was so much owed by so many to so few.
THE BATTLE OF BRITAIN, 20 AUGUST 1940

We shall defend our island. whatever the cost may be. we shall fight on the beaches. we shall fight on the landing-grounds. we shall fight in the fields & in the streets. we shall fight in the hills; we shall never surrender.
4 JUNE 1940

Let us therefore brace ourselves to our duties and so bear ourselves that if the British Empire and its commonwealth last for a thousand years, men will still say: 'This was their finest hour.'
18 JUNE 1940

We do not war primarily with races as such. Tyranny is our foe. Whatever trappings or disguise it wears, whatever language it speaks, be it external or internal, we must forever be on our guard, ever mobilised, ever vigilant, always ready to spring at its throat.

Fiel pero desdichado MOTTO

Victory, victory at all costs, victory in spite of all terror

Donald Jackson Famous sayings from the speeches and writings of
Sir Winston Churchill. Courtesy of Mr and Mrs Dan Kelley

62

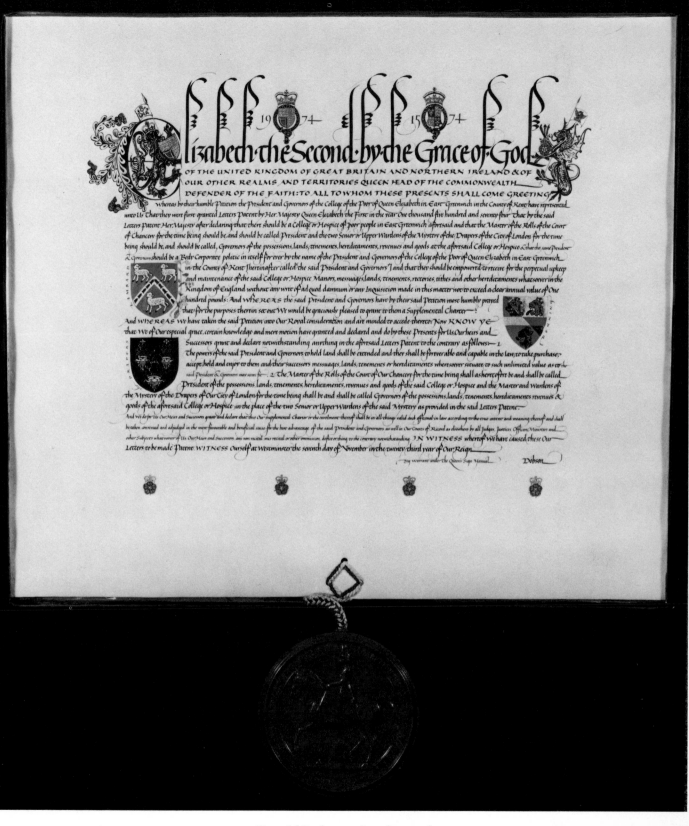

Donald Jackson Supplemental
Charter, 1974. Letters Patent of the
Worshipful Company of Drapers'
Almshouses in Greenwich,
Queen Elizabeth College.
Courtesy of the Drapers'
Company. Photo: John Blomfield

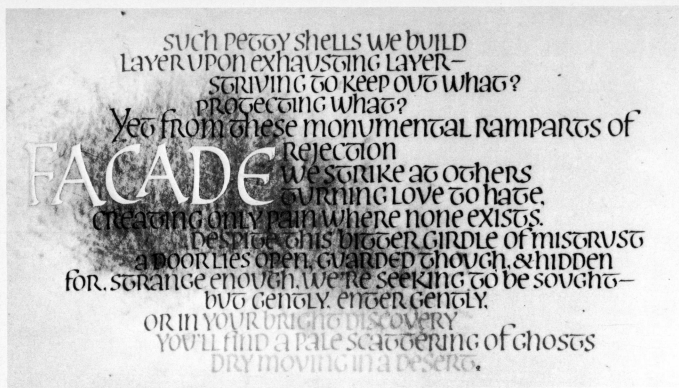

SUCH PETTY SHELLS WE BUILD
LAYER UPON EXHAUSTING LAYER—
STRIVING TO KEEP OUT WHAT?
PROTECTING WHAT?
Yet from these monumental ramparts of
FACADE REJECTION
WE STRIKE AT OTHERS
TURNING LOVE TO HATE,
CREATING ONLY PAIN WHERE NONE EXISTS.
DESPITE THIS BITTER GIRDLE OF MISTRUST
A DOOR LIES OPEN, GUARDED THOUGH, & HIDDEN
FOR. STRANGE ENOUGH. WE'RE SEEKING TO BE SOUGHT—
BUT GENTLY. ENTER GENTLY.
OR IN YOUR BRIGHT DISCOVERY
YOU'LL FIND A PALE SCATTERING OF GHOSTS
DRY MOVING IN A DESERT.

Charles Pearce 'Facade', a poem by George Griffiths. A spattered watercolour effect has been used on the vellum behind the writing, which is graduated in tone. The title is in burnished gold leaf

ORGANISTS

SAINT MARK'S OR
THE LORD MAYOR'S
CHAPEL

1764	Edmund Broderip
1779	Robert Broderip
1808	Cornelius Bryan
1840	William Sidney Pratten
1852	H.J.King
1853	Charles Robert Marston Powell
1867	George Williams
1867	Alfred Stone
1869	Arthur Crook
1873	Alfred Stone (reappointed)
1878-88	(Mrs) Maria Shackell
1889	Frank William Prosser
1893	Edmund Wheddon
1940	Joseph Graham Hooper

Irene Base Record of Organists at the Lord Mayor's Chapel, Bristol. Courtesy of J. Graham Hooper

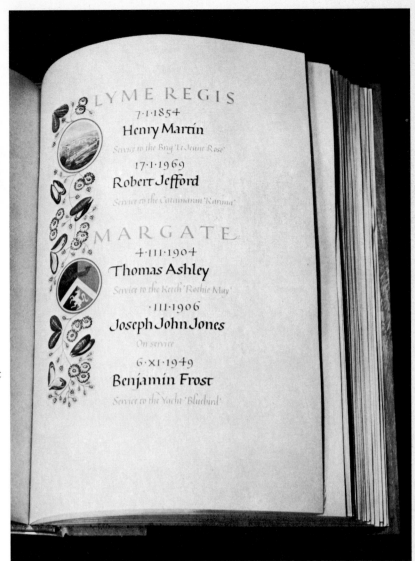

Lifeboat Service Memorial Book
Written and illuminated by five members
of the S.S.I. Layout and writing throughout
by Joan Pilsbury, borders by Margaret
Alexander, Wendy Westover and Wendy
Gould, miniatures by Wendy Westover,
heraldry by Heather Child and Joan
Pilsbury. Single page size 36·8 × 26·7 cm.
14½ × 10½ in.

Marie Angel From a Herbal Abecedarium
for the Hunt Institute of Botanical
Documentation, Carnegie-Mellon
University, Pittsburgh, Pennsylvania

THE QUICK BROWN FOX JUMPS OVER THE LAZY DOG. BASED ON SIMPLE UNCIALS OF THE 4TH CENTURY

The quick brown fox jumps over the lazy dog. Carolingian, 9 cent.

Foundational Hand based on 10th cent. English Carolingian abcdefghijklmnop qrstuvwxyz 123456789

The quick brown fox jumps over the lazy dog. A free, gothicized italic, based upon EJ's later hand, which can replace 'Old English'; Dense, black & decorative

The quick brown fox jumps over the lazy dog. Formal Italic freely written S·W

The quick brown fox jumps over the lazy dog - sharp, free, semi-formal italic - can be opened out and joined, or tightened

Sheila Waters A selection from exemplars of the major styles of formal penmanship, freely written without guide lines and intended for the use of students with some experience

The School of Bank Marketing
in cooperation with the University of Colorado
❦ awards to ❦
BRIAN CAMERON
this Certificate of Graduation
in consideration of the fulfillment of all requirements
completed in June, 1975

C. Harry Domun
PRESIDENT, BANK MARKETING ASSOCIATION

C. Hinkle
DIRECTOR, SCHOOL OF BANK MARKETING

And there cometh the Season
When any who hath a warm heart and akin with his neighbor
Layeth aside the saw if he be a worker in wood
Or the mallet if he be a mason, or whatsoever
Be the implement which is the mark of his craft.
And he gathered about him those who are of his hearth,
And goeth about amongst all his fellows
Who habit the same parish
Saying with much song and good cheer to all
"Peace and Good Will."

top
James Hayes Certificate of Graduation,
1975
bottom
Byron Macdonald A Christmas greeting

67

above
John Woodcock Book plate

John Woodcock Logotype

below
Sheila Waters One of 73 maps and diagrams for David Chandler's
Campaigns of Napoleon, published by Macmillan, New York, 1966

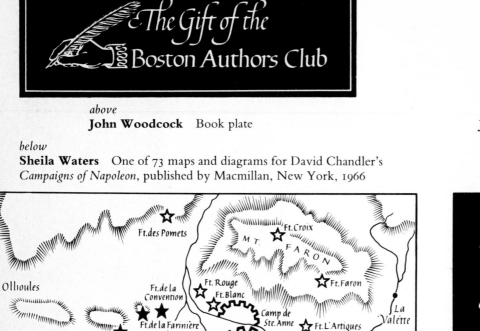

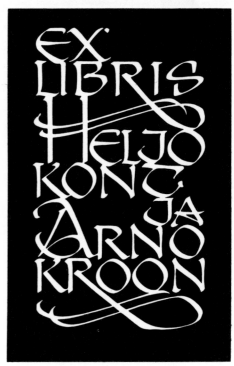

Villu Toots Book plate

James Hayes Book label

IT CAME UPON THE MIDNIGHT CLEAR,
THAT GLORIOUS SONG OF OLD
FROM ANGELS BENDING NEAR THE EARTH
TO TOUCH THEIR HARPS OF GOLD:—
'PEACE ON THE EARTH, GOOD WILL TO MEN,
FROM HEAVEN'S ALL GRACIOUS KING'!
THE WORLD IN SOLEMN STILLNESS LAY
TO HEAR THE ANGELS SING

Stuart Barrie Christmas card, reproduced by litho in two shades of red. Size 20·3 × 11·4 cm. 8 × 4½ in.

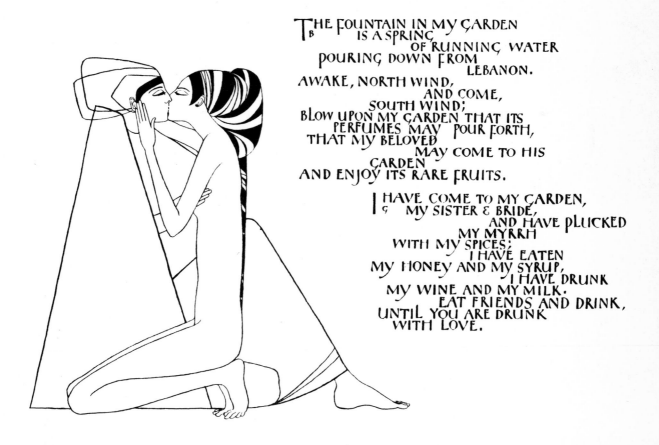

THE FOUNTAIN IN MY GARDEN
 IS A SPRING,
 OF RUNNING WATER
POURING DOWN FROM
 LEBANON.
AWAKE, NORTH WIND,
 AND COME,
 SOUTH WIND;
 BLOW UPON MY GARDEN THAT ITS
 PERFUMES MAY POUR FORTH,
 THAT MY BELOVED
 MAY COME TO HIS
 GARDEN
AND ENJOY ITS RARE FRUITS.

 I HAVE COME TO MY GARDEN,
 MY SISTER & BRIDE,
 AND HAVE PLUCKED
 MY MYRRH
 WITH MY SPICES;
 I HAVE EATEN
 MY HONEY AND MY SYRUP,
 I HAVE DRUNK
 MY WINE AND MY MILK·
 EAT FRIENDS AND DRINK,
 UNTIL YOU ARE DRUNK
 WITH LOVE.

Alison Urwick The Song of Songs transcribed from the New English Bible. The manuscript book has brush writing and tinted line drawings on very white, thin paper, 1973. Page size 29·8 × 24·1 cm. 11¾ × 9½ in.

THE ANGEL, GUILDFORD

The oldest part of the Angel is the stone-vaulted crypt which is possibly 13th century. In 1345 the White Friars erected a cross in the middle of the street opposite the inn, and this Fish Cross had on its summit a flying angel of stone which must have given the hostelry its name. A small metal lion found during alterations to the inn in 1951 is thought to be 14th century Eastern European in origin and to represent the lion of St. Mark from the arm of a crucifix.

In 1527 the house passed into the hands of the Mores of Loseley, and 100 years later was one of the "very faire Innes" mentioned by John Taylor, the water poet. In 1707 the Bailiff's Feast was held here, £4 being paid for wine. The landlord had to compound with his creditors in 1779 owing to the excessive billeting of troops on the house. In the 1840's The Times coach left here for Charing Cross daily via Epsom. The Prince Imperial of France stayed here in 1876.

W. Westover 1970

left
Wendy Westover History of the Angel Hotel, Guildford, for Trust House Forte, 1970

above
Sheila Waters Alphabet mural decoration. Black Versal capitals, italic and roman small letters in vermilion, 1974. Limited edition printed on Japanese Hosho paper by letterpress

A windy day with the white clouds

and the flung spray and the blown spume

and the sea gulls crying

Ruth Josslin Quotation from 'Sea Fever' by John Masefield. Written in an expanded Legende, black on hand-made paper. Size 27·3 × 67·3 cm. 10¾ × 26½ in.

The
courage to be
is the ethical
act
in which
man affirms
his own being
in spite of
those
elements of
his existence
which
conflict with
his
essential self-
affirmation

PAUL TILLICH

Written out by
Ann Camp
1973

left

Ann Camp Quotation from Paul Tillich, written out in black on grey Ingres paper, 1973. Size 35·6 × 20·3 cm. 14 × 8 in.

below

Joan Pilsbury Double opening from Book Two of William Wordsworth's *The Prelude*, written in a formal cursive hand, 1969. The manuscript contains 23 illuminations and one gilded initial. Page size 24·8 × 16·5 cm. 9¾ × 6½ in.

From early days,
Beginning not long after that first time
In which, a Babe, by intercourse of touch
I held mute dialogues with my Mother's heart,
I have endeavoured to display the means
Whereby this infant sensibility,
Great birthright of our being, was in me
Augmented and sustained. Yet is a path
More difficult before me; and I fear
That in its broken windings we shall need
The chamois' sinews, and the eagle's wing:
For now a trouble came into my mind
From unknown causes. I was left alone
Seeking the visible world, nor knowing why.
The props of my affection were removed,
And yet the building stood, as if sustained

By its own spirit! All that I beheld
Was dear, and hence to finer influxes
The mind lay open, to a more exact
And close communion. Many are our joys
In youth, but oh! what happiness to live
When every hour brings palpable access
Of knowledge, when all knowledge is delight,
And sorrow is not there! The seasons came,
And every season wheresoe'er I moved
Unfolded transitory qualities,
Which, but for this most watchful power of love,
Had been neglected; left a register
Of permanent relations, else unknown.
Hence life, and change, and beauty, solitude
More active even than 'best society'—
Society made sweet as solitude
By silent inobtrusive sympathies,
And gentle agitations of the mind
From manifold distinctions, difference
Perceived in things, where, to the unwatchful eye,

Survival
of the
poetic
vision in
Wordsworth

HERE ARE RECORDED THE NAMES OF THE BAILIFFS WHO [...] SERVED

"Bailiff" comes from Old French, from Late Latin ~baiulus~ originally a carrier, then one charged with administration & authority in a p[...]



1422 HENRY VI 1461

Year	No.	Name
1427	1428	John Galeway
1428	29	William Sharley
1429	30	Stephen Lescell
1430-1431		John Shalwell, Snr.
1431	32	One year unrecorded
1432	33	William Smyth
1433	35	Two years unrecorded
1435	36	Richard Glover
1436	37	James Ayllewyn
1437	39	Two years unrecorded
1439	40	Thomas Jan
1440-1441		One year unrecorded
1441	42	William atte Water
1442	43	John Godfrey or Fermor
1443	44	John Bate
1444	45	William Melale
1445	46	One year unrecorded
1446	47	Thomas Wynday
1447	48	William Godfrey or Fermor
1448	49	John Serlys
1449	50	John Fermor Jnr
1450-1451		John Serlys
1451	52	Thomas Wynday
1452	53	One year unrecorded
1453	54	John Hunt
1454	55	John Lecok
1455	57	Two years unrecorded
1457	58	Vincent Sedley
1458	59	One year unrecorded
1459	60	William Fermor
1460-1461		John Deken

1461 EDWARD IV 1483

1461	62	Andrew Bate
1462	65	Three yrs unrecorded
1465	66	John Breggis
1466	67	William Stokham
1467	68	Robert Howgh or Hothgt
1468	69	William Benet
1469	70	Thomas Gros or Groce
1470-1471		William Wanstall
1471	72	Thomas Caxton
1472	73	Thomas Gros or Groce
1473	74	Henry Bate
1474	75	Henry Bate
1475	76	John Kempe
1476	77	John Kempe
1477	78	Henry Bate

Column 2

1478	79	Thomas Gros or Groce
1479	80	Thomas Gros or Groce
1480-1481		Stephen Lecok
1481	82	Thomas Gros or Groce
1482	83	John Kempe

April 1483 EDWARD V

1483 RICHARD III 1485

| 1483 | 84 | Thomas Gros or Groce |
| 1484 | 85 | Thomas Gros or Groce |

HENRY VII

1485	86	One year unrecorded
1486	87	Lawrence Gros
1487	88	One year unrecorded
1488	89	Lawrence Gros
1489	1509	Twenty yrs unrecorded

1509 HENRY VIII 1547

1509	16	Seven years unrecorded
1516	17	William Adam
1517	18	William Adam
1518	19	John Bate
1519	20	John Bate
1520-1521		Robert Horsley
1521	22	Robert Horsley
1522	23	William Adam
1523	24	Thomas Strogull
1524	25	Robert Ferrard
1525	26	Thomas Swan
1526	27	Robert Robin
1527	28	Andrew Bate
1528	29	Thomas Strogull
1529	30	John Cawston
1530-1531		Richard Stuppeny
1531	32	Andrew Bate
1532	33	Thomas Godfrey
1533	34	Thomas Godfrey
1534	35	Thomas Smyth
1535	36	Thomas Tye
1536	37	Simon Gason
1537	38	Simon Tipper
1538	39	John Kempe
1539	40	Thomas Strogull
1540-1541		William Grenewey
1541	42	Simon Nicoll
1542	43	Robert Robyn
1543	44	Simon Gason
1544	45	Alen Epps

Column 3

| 1545 | 46 | Thomas Strogull |
| 1546 | 47 | Thomas Bate |

1547 EDWARD VI 1553

1547	48	Thomas Bate
1548	49	William Barrowe
1549	50	Peter Godfrey
1550-1551		John Kempe
1551	52	Thomas Cutter or Cutterd
1552	53	Simon Gason

1553 JANE GREY July 10, 1553

1553 MARY I 1558

1553	54	John Strogull
1554	55	William Barrowe; Thomas Harte
1555	56	Peter Godfrey
1556	57	Thomas Harte Jnr.; Nicholas Pyx
1557	58	William Butcher

1558 ELIZABETH I 1603

1558	59	Thomas Bate
1559	60	John Kempe
1560-1561		Nicholas Pyx
1561	62	Thomas Harneden
1562	63	John Berrye
1563	64	William Bate; Thomas Bate
1564	65	John Strogull
1565	66	John Cockerell
1566	67	Richard Buntyng
1567	68	Clement Stuppenye
1568	69	William Smythe
1569	70	John Berrye
1570-1571		Thomas Harneden
1571	72	John Bate
1572	73	Clement Stuppenye
1573	74	Thomas Godfrey
1574	75	John Hebylthwayte
1575	76	John Bateman
1576	77	John Berrye
1577	78	Thomas Harneden
1578	79	Thomas Harneden
1579	80	Clement Stuppenye
1580-1581		Thomas Godfrey
1581	82	George Whytebone
1582	83	Thomas Knight
1583	84	Clement Stuppenye

Column 4

1584	85	Thomas Harneden
1585	86	John Berrye
1586	87	Thomas Godfrey, Jnr.
1587	88	Thomas Godfrey, Jnr.
1588	89	Robert Tokey
1589	90	Alexander Weston
1590-1591		William Pallett
1591	92	Clement Stuppenye
1592	93	John Berrye
1593	94	Thomas Godfrey
1594	95	John Wells
1595	96	Thomas Knight
1596	97	John Wilcocke / William Dillen
1597	98	Clement Stuppenye
1598	99	John Strogull
1599	1600	John Berrye
1600-1601		Clement Bate
1601	'02	Thomas Bate
1602	'03	William Glover

1603 JAMES I 1625

1603	04	Thomas Godfrey
1604	05	Thomas Godfrey
1605	06	John Berrye
1606	07	John Berrye
1607	08	Clement Stuppenye
1608	09	Clement Bate
1609	10	Thomas Knight
1610-1601		Peter Maplisden
1611	12	Lawrence Stuppenye
1612	13	John Berrye
1613	14	Thomas Stroughill
1614	15	William Wilcocke
1615	16	Peter Godfrey
1616	17	Thomas Godfrey
1617	18	Thomas Bate
1618	19	Peter Maplisden
1619	20	John Allen
1620-1621		John Allen
1621	22	Clement Bate
1622	23	William Wilcocke
1623	24	William Wilcocke
1624	25	Thomas Stroughill

1625 CHARLES I 1649

1625	26	Thomas Stroughill
1626	27	John Glover
1627	28	John Glover
1628	29	Thomas Bate, Snr
1629	30	Thomas Bate, Jnr

Column 5

1630-1631		Peter Maplisden
1631	32	William Godfrey
1632	33	Stephen Browne
1633	34	Thomas Stroughill, Jnr.
1634	35	Thomas Bate, Snr.
1635	38	Three years unrecorded
1638	39	John Glover
1639	40	Clement Tipp
1640-1642		Two years unrecorded
1642	43	Richard Glover
1643	44	Thomas Stroughill
1644	45	Clement Tipp
1645	46	Richard Bate
1646	47	Richard Glover
1647	50	Three years unrecorded

CHARLES II 1685

1650-1651		Stephen Durrant
1651	52	Stephen Durrant
1652	53	Edward Ashie
1653	54	Richard Rennett
1654	55	Richard Bate
1655	56	Richard Bate
1656	57	Thomas Higginson
1657	58	James Bate
1658	59	John Stroughill
1659	60	Edward Cullemben
1660-1661		Edward Cullemben
1661	62	John Knight
1662	63	John Bartholomew
1663	64	Michael Chidwick
1664	65	John Bateman
1665	66	John Bateman
1666	67	Thomas Bateman
1667	68	Edward Cullemben
1668	69	Edward Cullemben
1669	70	Edward Cullemben
1670-1671		William Sudell
1671	72	William Sudell
1672	73	John Bateman
1673	74	Henry Potter
1674	75	William Sudell
1675	76	William Sudell
1676	77	William Glover
1677	78	William Glover
1678	79	John Barton
1679	80	John Barton
1680-1681		John Barton
1681	82	William Ringsmill
1682	83	John Bateman

"Hundred" An old admin. divn. of County or Shire, having its own court~perhaps originally containing one hundred hides: "hide"~a sq. m[...]

The great storm of 1287 caused the inundation of the sea & the whole coast line changed. The river Rother changed its course... no longer flowing out to sea through a large tidal haven which separated Lydd from the flourishing Cinque Port of Romney. This marked their decline as ports: harbours silted up; Lydd became further from the sea as the vast stretches of shingle built up at Dunge-Nesse- name of Danish origin meaning "Danger" Cape. ... it was here that Watch Fires were lighted & here too Watch was kept against the coming of the French. ... constantly records response to this danger point where now stands a Nuclear Power Station.

For all things change, the darkness changes, the wandering spirits change their ranges, the corn is gathered to the granges.

This Record of the Bailiffs of Lydd has been largely compiled from "Records of Lydd" which book was edited by Arthur Finn in 1911: also from the [...]

Irene Wellington Bailiffs of Lydd. A framed panel on vellum in the Council Chamber, Guildhall, Lydd, Kent. The names recorded are written in Roman Minuscules, the most compact letter form, to give weight and legibility at eye level. The capitals in the top panel are drawn with a pen and add a decorative element. The title in black and white capitals is painted on a wide band of matt gold. The three lines written in a larger, strong, compressed hand are invaluable in giving a less abrupt change in scale: the first and second lines enclose the columns of names at the top and bottom and the second and third enclose the notes and verse at the base, which are written in a free italic. Size 86·4 × 104·1 cm. 34 × 41 in.

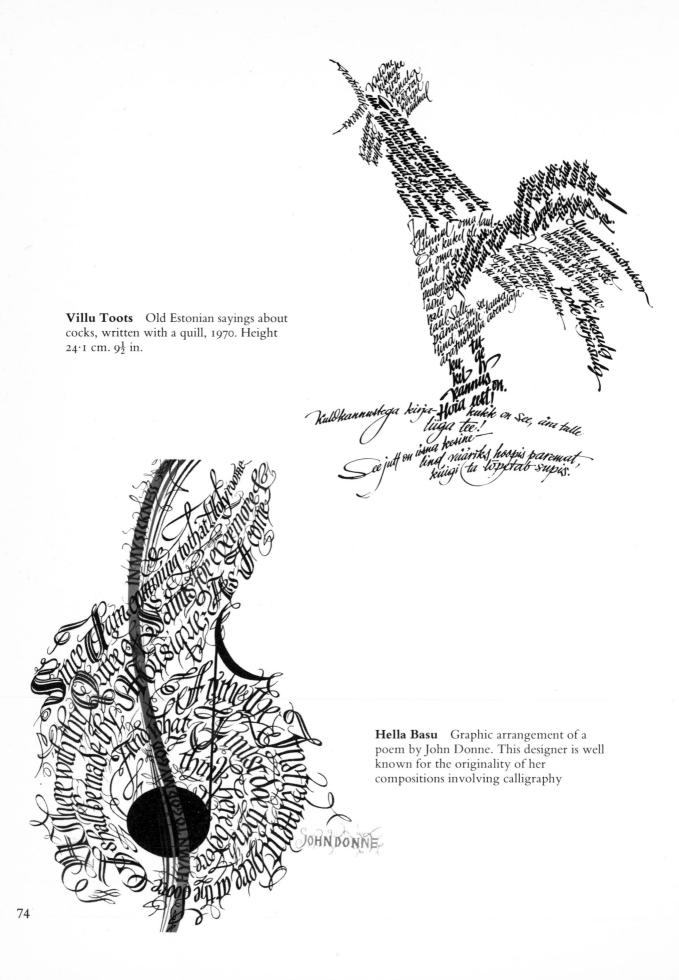

Villu Toots Old Estonian sayings about cocks, written with a quill, 1970. Height 24·1 cm. 9½ in.

Hella Basu Graphic arrangement of a poem by John Donne. This designer is well known for the originality of her compositions involving calligraphy

74

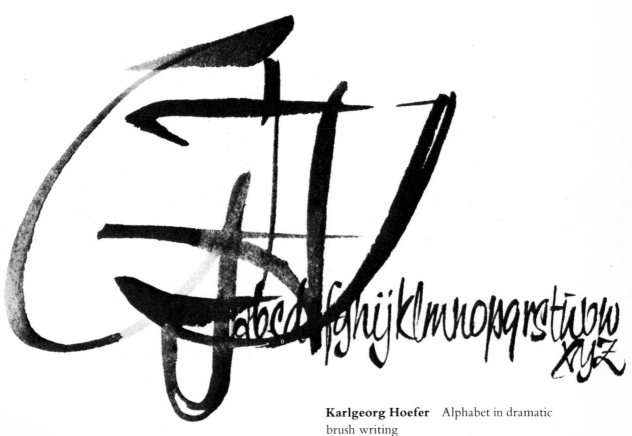

Friedrich Neugebauer
Quotation from Rainer Maria
Rilke. Victoria and Albert
Museum (Circ. 294 1966)

Karlgeorg Hoefer Alphabet in dramatic
brush writing

75

above
Max Caflisch Advertisement for a
publisher

Hedwig Reiner A title page in two
colours from *Lettering in Book Art*

below
Robert Palladino Christmas card

Jan van Krimpen Monogram

"THERE IS NOTHING MORE FITTING
THAT COULD BE FOUND IN THE PLENI-
TUDE OF THE DIVINE BOUNTY WITH
WHICH TO HONOR THIS FEAST THAN

PEACE "

ST. LEO (449 A.D.)

we wish you this peace today

Robert · Catherine · Cathy & Eric Palladino

76

The spirit of man is the candle of the Lord

David Peace Design for engraving one of the glass sconces for the candlesticks on the lectern in Chester Cathedral

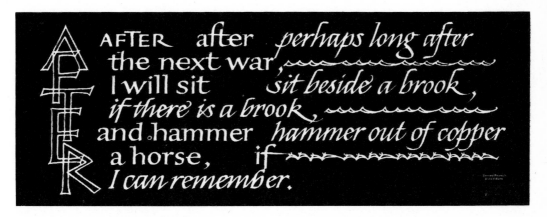

AFTER after perhaps long after
the next war,
I will sit sit beside a brook,
if there is a brook,
and hammer hammer out of copper
a horse, if
I can remember.

Arnold Bank 'After' by David Petesh, one of twelve poems written by various poets for display on the Pittsburgh buses. Designers' white on copper-orange coloured board, 1975. Size 71·1 × 27·9 cm. 28 × 11 in.

77

The Chaos about thee is but the Confusion within thee.

2120 VINE STREET
BERKELEY CA 94709

The Artifactrie

OPEN EVERY DAY *from* 10 *to* 6 843-9440

above
Georgianna Greenwood Trade card

left
Rick Cusick Calligraphic exercise

below
Egdon Margo Greetings in Spanish

Alegría y felicidades en la Semana de la Secretaria

PAX shalom PAIX salam FRIEDE PACE

Marie Angel From *Two by Two*, an Alphabet Bestiary in Spanish and English, with text by Tony Talbot. Published by the Follett Publishing Co., Chicago

Rick Cusick Personal New Year greetings

top row
Diana Bloomfield Book label; **Wendy Westover** Device for documents; **Diana Bloomfield** Book label

2nd row
Chris Brand Monogram for a publisher; **Diana Bloomfield** Book label; **Chris Brand** Monogram for a birthday card

3rd row
W. A. Dwiggins Book label; **Villu Toots** Jubilee monogram; **James Hayes** Book label

4th row
Georgianna Greenwood Monogram; **James Hayes** Book label; **Chris Brand** Monogram

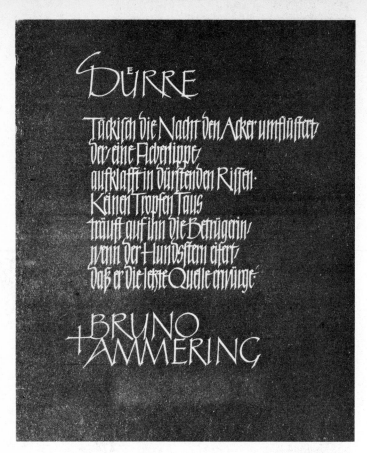

Friedrich Neugebauer
Quotation from Bruno Ammering.
Victoria and Albert Museum
(Circ. 295 1966)

Die Weihnachtsgeschichte

ES BEGAB SICH
ABER Z_V^DER ZEIT D_A^SS
E_I_N GEBOT V_N° D_ME
K_I^A_S^E_R AVGVSTVS

ausging das alle welt geschätzt
würde ◆ Und diese schätzung
war die allererste und geschah
zu der zeit da cyrenius land-
pfleger in syrien war ◆ Und ie

Max Waibel The Birth of
Christ. Extracts from the Gospel
accounts of SS. Luke, John and
Matthew. Victoria and Albert
Museum (Circ. 166 1966)

80

Friedrich Poppl These freely written letters, with their generous proportions and close spacing between lines, make a vibrant pattern on the rough watercolour paper. Victoria and Albert Museum (Circ. 162 1966)

Another example from the same calligrapher with white letters on a dark ground

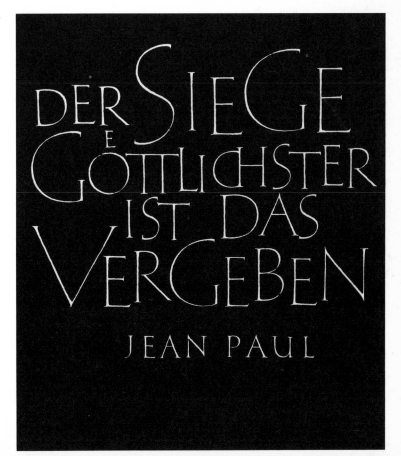

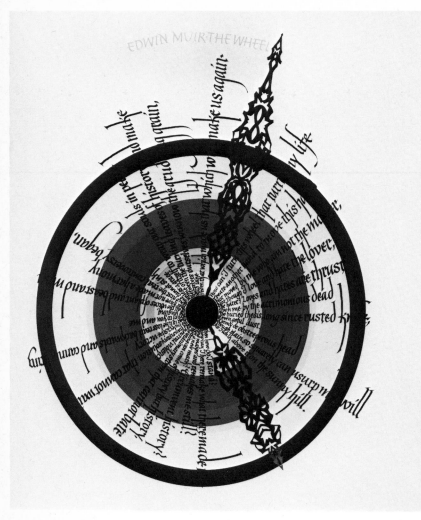

Hella Basu 'The Wheel' by Edwin Muir.
Evocative transcription of a modern poem

David Williams From the Book of
Amos 5:8. Vellum panel with gold letters
and a green-toned background

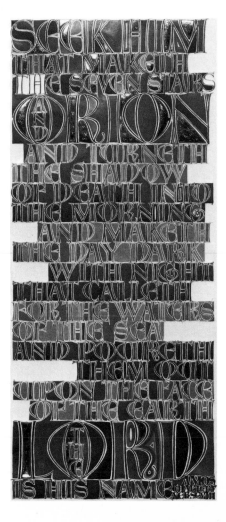

82

EBONY LANE AND POUND LANE

...el·corylus avellana ✤ dog's mercury mercurialis perennis ✤ primrose·primula ...aris ✤ wood anemone·anemone nemo... ...✤ blackthorn·sloe·prunus spinos... ...beam·carpinus betulus ✤ Lady's ...ock·cardamine pratensis ✤ Quee... ...s lace·anthriscus sylvestris ✤ oak·... ...obur ✤ ash·fraxinus excelsior ✤ v... ...sativa ✤ goose grass·galium ap... ...d maple·acer campestre ✤ woodyle·bittersweet·solanum dulca... ...ony·tamus communis ✤ honeys... ...era periclymenum ✤ bramble... ...cosus ✤ dog rose·rosa canina ✤stachys sylvatica ✤ convo... ...stegia sepium ✤ codlins a... ...epilobium hirsutum ✤

To Serena Gardner from William Gardner

the eleventh day of May, 1974, Chequertree ✤

Twenty-one growing things—not to mention bullace, elder, cow parsnip, cat's tail, trailing rose, silverweed, hawkweed, ivies, clovers, buttercups, dandelions, figwort, plantains, nettles, thistles, docks, trefoils, and grasses innumerable.

William Gardner Record of the names of wild flowers growing in the lanes behind the scribe's home in Kent. An exercise in the formal italic hand. The names, in English and Latin, are written across inlaid coloured papers which 'move' from wintry white through grey, pale green and dark green, to autumn tints and black to white

83

Dem hochverdienten, vorbildlichen
Schreibmeister und Wiedererwecker
der Italic-Handschrift

Alfred Fairbank

gratuliere ich von ganzem Herzen
zu seinem siebzigsten Geburts-
tag. Möge die Vorsehung für Sie
noch viele Jahre fruchtbarer, freu-
diger Arbeit bringen. In grosser
Verehrung grüsst Sie zum 12·7·1965
aus der Schweiz Ihr Walter Kaech

Walter Kaech A tribute to Alfred
Fairbank on his seventieth birthday in 1965

Paul Standard Book jacket for his
wife's cookery book

FASHION
DESIGN
AWARD
1972

the international wool secretariat & welsh textiles limited

this is to certify that.
has the greatest number of entrants in the final fifty of their
national fashion competition, held at the park hotel, cardiff,
on monday 6th november 1972 in the presence of the rt.hon.
the lord mayor of cardiff - alderman mrs winifred mathias.

fashion advisor to the i.w.s. chairman of the judges. managing director welsh textiles ltd

above
Ieuan Rees Certificate for a Fashion
Design Award, written on goatskin
parchment. Size 15·2 × 41·9 cm. 6 ×
16½ in.

below
Jacqueline Svaren Carolingian page
from her book *Written Letters*, comprising
twenty-two alphabets for calligraphers,
published by The Bond Wheelwright
Company, Freeport, Maine, 1975

11

As is the case with much of the history of the letters,
there is disagreement concerning the origin of the
half-uncial. Some paleographers feel that half uncial
is the natural next step after uncial, evolving as
the hand moves faster allowing strokes to merge &
corners to round. In the handsome book DIE ENTWICKLUNG DER LATEINISCHEN [16]
SCHRIFT it is stated
that the half-uncial
is a mixed form based
on earlier mixed
roman bookhands
& Roman cursive.
(The 3 is very obviously
the result of wax tab
let cursive, but the
τ & N are just as
firmly based in the
uncial.) I, therefore,
feel that the half-
uncial shows strong
influences from both
sources.

The long s, or ſ
might seem
strange to you
until you un-
derstand its
evolution:
ſ ſ ſ r r

No one serious
ly involved in
letters would
confuse it with
the f. The ſ
stops at the
base line, while
f drops below: f
has a cross bar,
ſ does not, &
of course, the
word helps dif-
ferentiate.

the half uncial as written at

tours in the ninth century is

spacious and heartbreakingly

beautiful. the body height is

only 2 pens, but the huge space

left between lines of writing

(about 14 pens) combined with

very generous counters gives

a very open feeling to the page.

As you write it,
please keep the majus-
cule in mind. Al-
though this alphabet
flows much more
readily than the uncial,
it should still be stately
& should remain ver-
tical. Don't fall into
the trap of consider-
ing it to be a
minuscule.

This page is based
on letters written
in Tours AD 850.
The facimile in
1000 YEARS OF
CALLIGRAPHY
was my model.

Please be careful to differentiate between half-uncial & Carolingian.
To the inexperienced eye they are very similar. The letters which
show the most obvious distinctions are a·3·l·n·&·r. It would
be a mistake to substitute the a, g, l, n or r of Caroline.

This page was written with a Wm
Mitchell Cursive No. 7 nib.

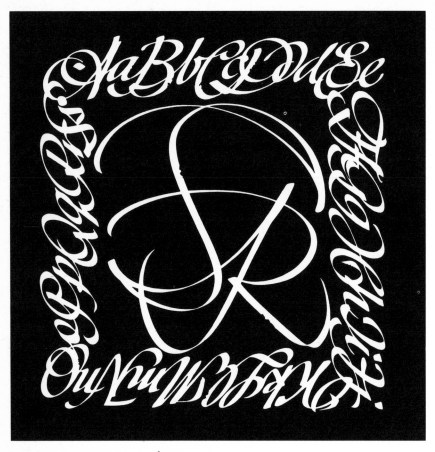

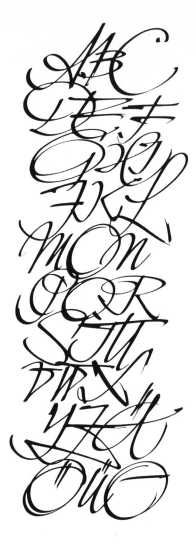

above
Villu Toots A study with a quill, 1970.
Height 25·4 cm. 10 in.

right
Villu Toots Another study with a quill,
1972. Height 25·4 cm. 10 in.

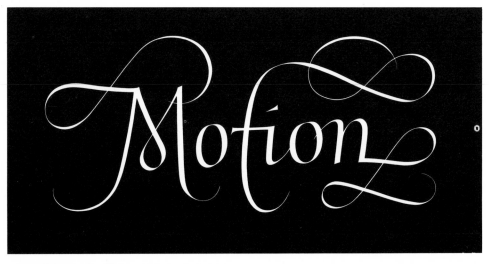

Ann Camp Brush lettering in designer's
gouache, white on red Swedish paper

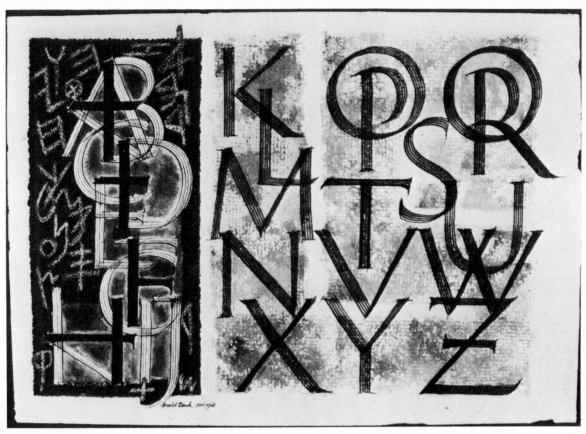

Arnold Bank Roman capitals written on
watercolour paper, interlaced with
Phoenician script, 1966

below
Arnold Bank Free-style capitals written in
black and grey with colours on watercolour
paper, 1967. Size 55·9 × 39·4 cm. 22 × 15½ in.

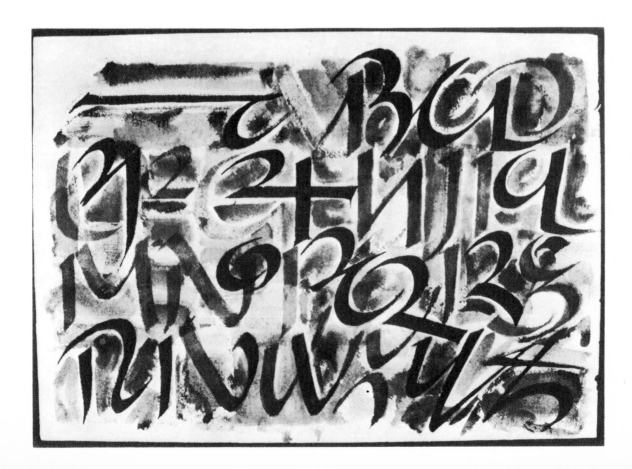

87

I SING of a maiden
that is makeles
King of alle kinges
To here sone che ches

he cam also stille
ther his moder was
as dew in Aprille
that fallith on the gras

he cam also stille
to his moderes bowr
as dew in Aprille
that fallith on the flowr

he cam also stille
ther his moder lay
as dew in Aprille
that fallith on the spray

Moder and maiden
was never non but che
wel may swich a lady
Godes moder be:

SO GOOD-LUCK
CAME
AND ON
MY ROOFE
DID LIGHT
LIKE
NOYSE-LESSE
SNOW

or as the dew of night

NOT ALL
AT ONCE
BUT
GENTLY
AS THE
TREES ARE,
BY THE
SUNBEAMS,
TICKEL'D BY
DEGREES

Ann Hechle Christmas and New Year
greetings. Left: early English carol.
Right: a poem by Robert Herrick. The
black and gold stars link the two ideas
together. Note the hair marks and veins in
the delicate vellum

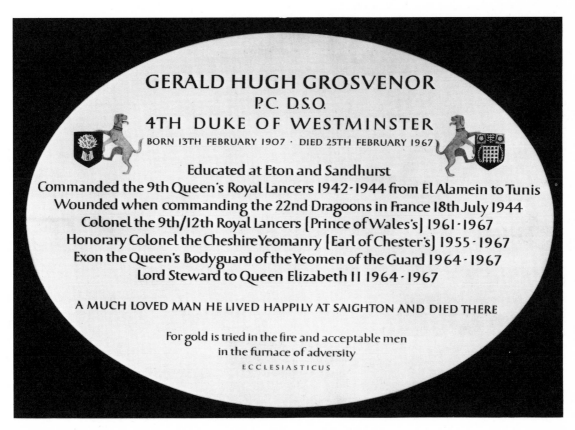

POSTREMO PENSANDVM
Finally, we must consider-
· QUANTA DOCTRINÆ COMMODITAS SIT
what pleasantness of teaching there is
<small>RICHARD DE BVRY</small> IN LIBRIS, <small>PHILOBIBLON 1:9</small>
in books,
QVAM FACILIS, QVAM ARCANA·
how easy, how secret!
QVAM TVTO LIBRIS HVMANÆ IGNORANTIÆ
How safely we lay bare the poverty of human ignorance to books
PAVPERTATEM SINE VERECVNDIA DENVDAMUS!
without feeling any shame!
HI SVNT MAGISTRI QVI NOS INSTRVVNT
They are masters who instruct us
SINE VIRGIS ET FERVLA, SINE VERBIS ET CHOLERA,
without rod or ferrule, without angry words,
SINE PANNIS ET PECVNIA: SI ACCEDIS, NONDORMIVNT;
without clothes or money. If you come to them they are not asleep:
- SI INQVIRENS INTERROGAS, NON ABSCONDVNT;
if you ask and enquire of them, they do not withdraw;
NON REMVRMVRANT SI OBERRES;
they do not chide if you make mistakes;
CACHINNOS NESCIVNT, SI IGNORES·
they do not laugh at you if you are ignorant·

John Woodcock Richard de Bury's *Philobiblon*. Calligraphy in
brown and black on paper. Courtesy of Boston Public Library, Massachusetts

GERALD HUGH GROSVENOR
P.C. D.S.O.
4TH DUKE OF WESTMINSTER
BORN 13TH FEBRUARY 1907 · DIED 25TH FEBRUARY 1967

Educated at Eton and Sandhurst
Commanded the 9th Queen's Royal Lancers 1942·1944 from El Alamein to Tunis
Wounded when commanding the 22nd Dragoons in France 18th July 1944
Colonel the 9th/12th Royal Lancers [Prince of Wales's] 1961·1967
Honorary Colonel the Cheshire Yeomanry [Earl of Chester's] 1955·1967
Exon the Queen's Bodyguard of the Yeomen of the Guard 1964·1967
Lord Steward to Queen Elizabeth II 1964·1967

A MUCH LOVED MAN HE LIVED HAPPILY AT SAIGHTON AND DIED THERE

For gold is tried in the fire and acceptable men
in the furnace of adversity
ECCLESIASTICUS

Wendy Westover Memorial inscription on vellum. The writing is in
black, the quotation from Ecclesiasticus in blue, the heraldry in colour,
raised and burnished gold by Joan Pilsbury. Size 101·6 × 71·1 cm. 40 × 28 in.

Mr & Mrs Reynolds Stone
request the pleasure of
your company at the marriage
of their daughter
Phillida
to
Jonathan Gili
at St Mary's Church
Litton Cheney
1·30 p.m. 27 July 1968
& afterwards at the Old Rectory

CASTLE
Official Guide

Reynolds Stone Page of examples of the work of this distinguished engraver

Die Bücher sind einzelne Kapellen, die der Mensch in den wildromantischen Gegenden des Lebens auf den höchsten und schönsten Standpunkten errichtet, und auf seinen Wanderungen nicht bloß der Aussicht wegen, sondern hauptsächlich deswegen besucht, um sich in ihnen von den Zerstreuungen des Lebens zu sammeln und seine Gedanken auf ein anderes Sein, als nur das sinnliche, zu richten.

LUDWIG FEUERBACH

Friedrich Poppl Quotation from Ludwig Feuerbach. Author's collection

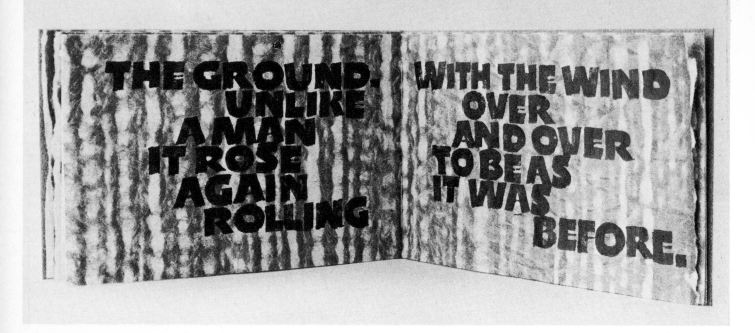

Pat Russell Black pen-made block letters on coffee and white striped Japanese paper. One verse from the poem 'The Tern' by William Carlos Williams written on each page. Page size 15·2 × 10·2 cm. 6 × 4 in.

Karlgeorg Hoefer Page from his *Book of Brush Studies*. The title, *Pinselstudien*, in dull gold, the brush lettering in black and grey. Victoria and Albert Museum (Library)

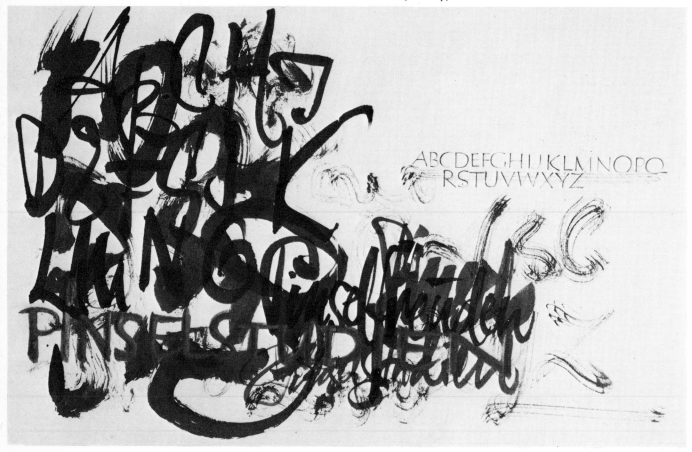

above
Maury Nemoy Quotations from Bertrand Russell. Variegated writing with a reed pen in colour, with the italic in black on white paper, 1974. Size 50·8 × 66 cm. 20 × 26 in.

below
Alison Urwick *The Rubáiyát of Omar Khayyám* translated by Edward Fitzgerald, written and decorated in rich Persian blues and greens, 1975. Page size 43·2 × 30·5 cm. 17 × 12 in.

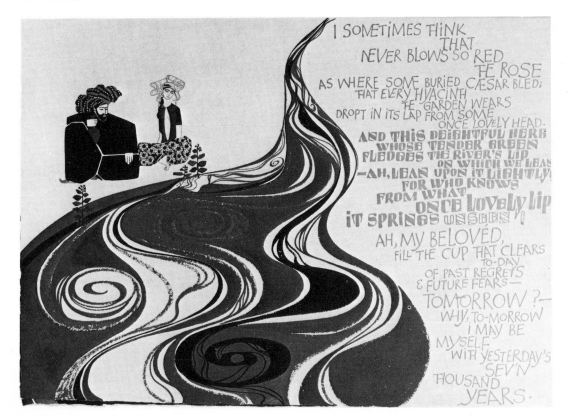

Kenneth Breeze Device for a coffee house

A. K. Ebsen Admission card

Dream
what you dare to dream,
Go where you want to go,
Be what you want to be...

Rick Cusick Calligraphy for a jig-saw puzzle, published by Hallmark Cards, Inc.

ADMIT TWO TO *the Toronto Montessori Parents' Guild's* COCKTAILS 7:00 · DINNER 8:00 p.m.
Valentine Dinner Dance
$20.⁰⁰ per couple *at the BayView Country Club, February 10, 68*

Thank you

Egdon Margo One of a series of courtesy cards

MARCIA DE SONNE AND ANDREW EZZELL ARE
HAPPY TO ANNOUNCE THAT THEY WILL BE
MARRIED ON THE TWENTY-SIXTH DAY OF
APRIL, NINETEEN HUNDRED AND SEVENTY-FIVE.
THE WEDDING IS TO BEGIN AT TWELVE NOON
AT SAINT ELIZABETH'S CHURCH, ROCKVILLE,
MARYLAND. THE CELEBRATION WILL
CONTINUE IMMEDIATELY AFTERWARD AT
THE ROCKVILLE CIVIC CENTER MANSION.
PLEASE COME AND HELP US CELEBRATE
THIS JOYOUS OCCASION.

Jenny Mitchell Wedding invitation

Edward A. Karr Book plate

below
Eugen Kuhn Greetings card

Meine Zeit stehet in deinen Händen.

Kenneth Breeze Hand-painted lettering
on formica

right
Raymond DaBoll Title page to a *Book
of Recollections* by Irene Briggs DaBoll

Exciting-humorous-poignant—The experiences of a young Soprano
in training and "on the road" for the Redpath Lyceum Bureau which
provided various forms of Educational Entertainment throughout the
United States in an era now almost forgotten, but important in guiding
the cultural development of America around the turn of the 20th century. 95

HERALDIC
DESIGN

Heather Child

above

Heather Child Jacket for her own book.
Scarlet background with black and white
lettering. The shield and lion are blocked in
gold. This was the first use of heat-stamped
gold leaf on a book jacket in England, in 1965

below

Heather Child Written title page, with
drawings by Dorothy Colles

תורה נביאים וכתובים

THE HOLY
SCRIPTURES

ACCORDING TO THE
MASORETIC TEXT

APPROVED VERSION OF
THE JEWISH PUBLICATION SOCIETY OF AMERICA

above

Lili Cassel Wronker Book jacket for a
Hebrew–English version of the Holy
Scriptures

Christian
Symbols

Ancient & Modern
a Handbook for Students

Heather Child
and Dorothy Colles

LONDON: G. BELL AND SONS

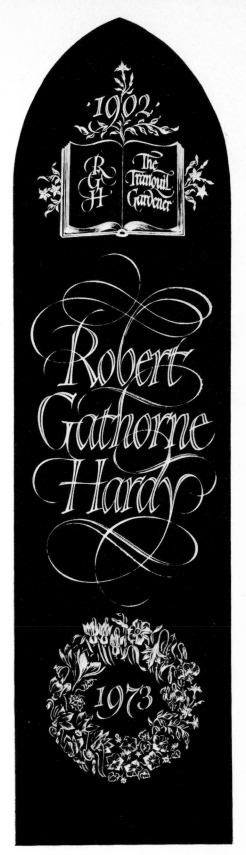

Madeleine Dinkel Book jacket designs
for the 'Wisdom of the East' series,
published by John Murray, London.
Printed by two-colour letterpress, with the
title reversed on white, the name of the
series and author in black. The backgrounds
are red, dull yellow and crimson. Height
19 cm. 7½ in.

Madeleine Dinkel Memorial window
for Robert Gathorne-Hardy, St Denis
Church, Stanford Dingley, Berkshire.
Engraved plate glass. Size 106·7 × 29·2 cm.
42 × 11½ in. 97

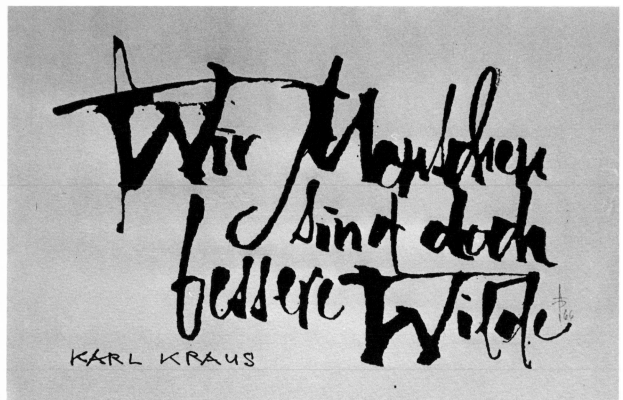

THE CITY WAS PURE GOLD LIKE UNTO CLEAR GLASS

REVELATION 21·18

Hermann Zapf A freely drawn pen and ink inscription with the reference in gold. Courtesy of David Peace Esq.

Friedrich Poppl Freehand brush writing in which the speed of movement is clearly demonstrated

KARL KRAUS

a Dollarti *Martist*

W·A·D
Bill Dwiggins
A memorial
for serious fun
Stan -¦-
Quintadeen 8

*She slowly
running
Hand*

The history
of the
flexible pen

fluence
of Jan

(Great
Quint Quint 2⅔
2'⅔
Small writing for
Design. A B C D E
article from font
abcdefg

(Quint 2⅔ (Quin t f t l faain quaint
Hoofdwerk Prestant 4 *Fagot 16*
The organ of St. John *J Praed.*
fagot ⸗ Small writing
(Sma) Small writing

Sample Sheet for Heather Child
[Small enough to reproduce in actual size]

above
Gerrit Noordzij Experimental page of
writing

below
Friedrich Poppl Quotation from Horace
in black and red. The tooth in the surface
of the paper gives a vigorous rough–edged
style to the elegant letters. Victoria and
Albert Museum (Circ. 161 1966)

BREVIS
ESSE
LABORO

*Ich
bemühe mich
kurz zu sein*

Horaz

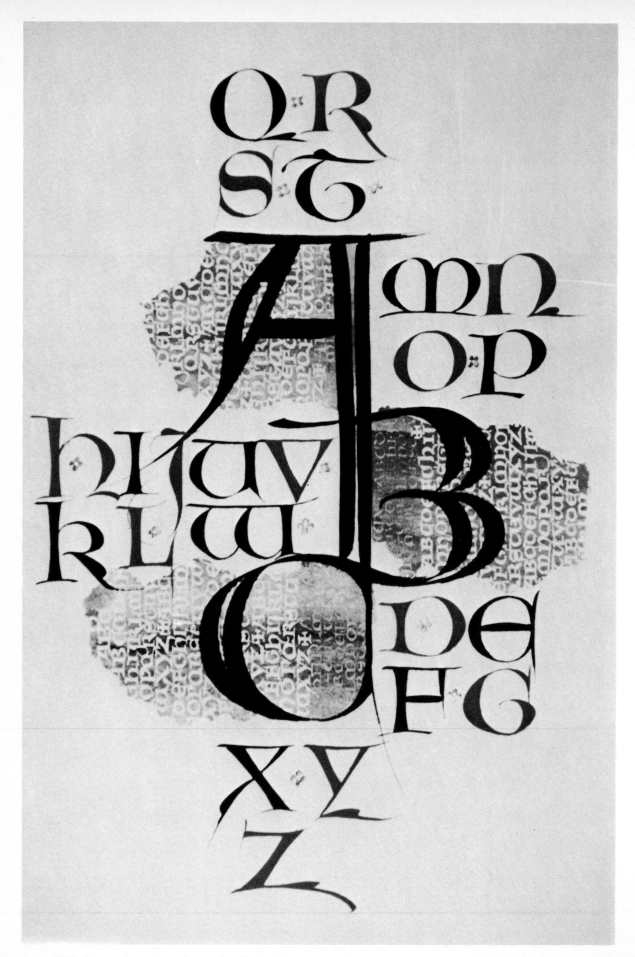

Donald Jackson Two pages from a book of *Alphabets and Quotations*
on vellum, carried out for Señor G. Rodriguez, 1972. Size 35·6 × 30·4 cm. 14 × 12 in.

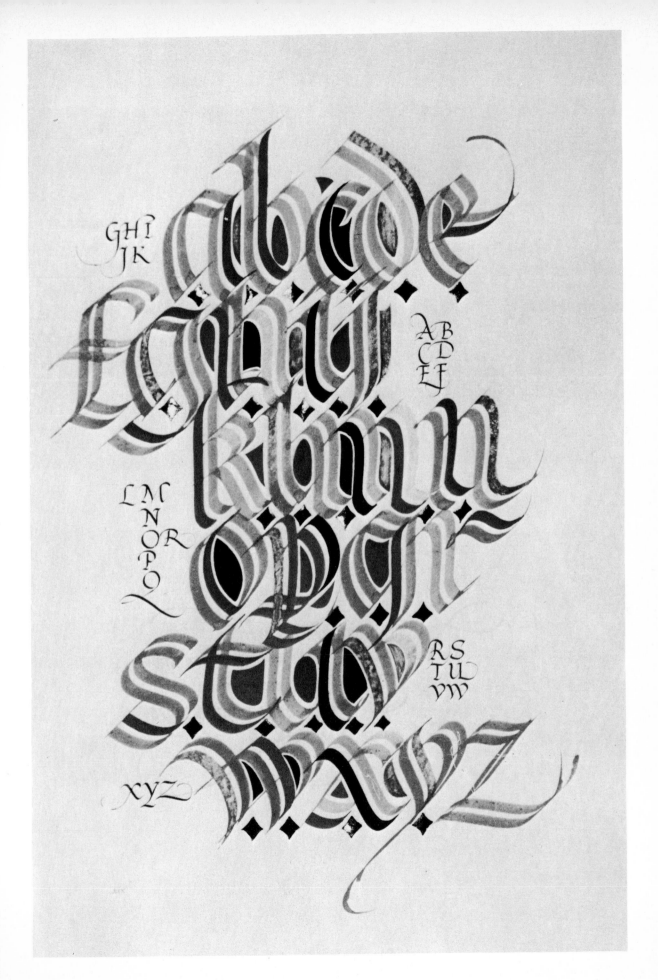

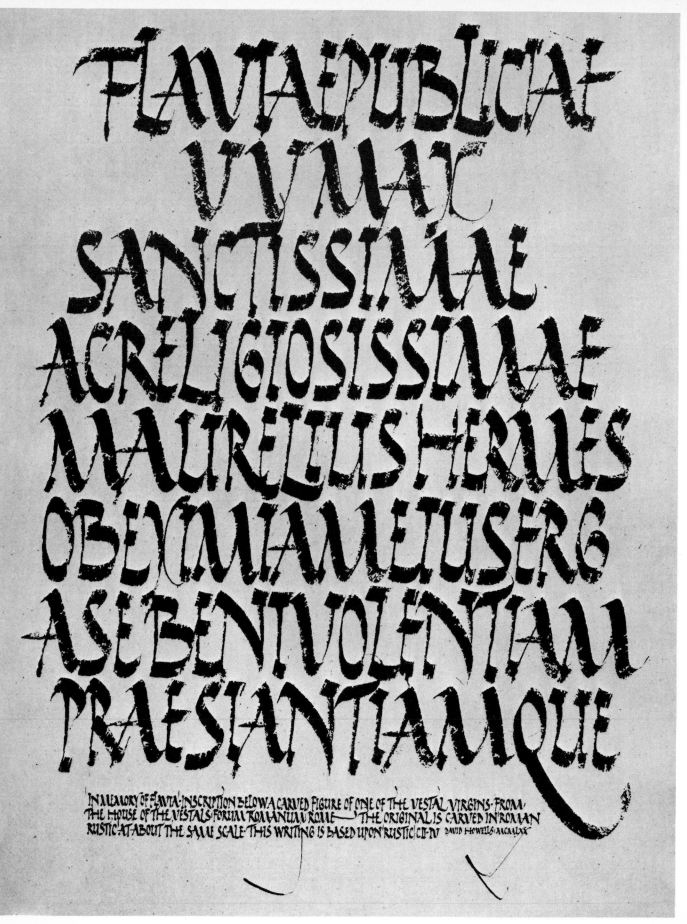

David Howells Panel of writing in Rustic capitals in black and red
on coarse-grained oatmeal paper. From an inscription in Rome in
memory of Flavia, one of the Vestal Virgins. Size 78·7 × 55·9 cm.
31 × 22 in.

IN HEVENE
AND HELLE
IN EARTHE AND
SALTE SEA
FROM
TROILVS
& CRISEIDE
BOOK III
IS FELT THY
MIGHT IF THAT
I WEL
DIS
CERNE
AS MAN
BRID · BEST
FISSH · HERBE
AND GRENE TREE

THEE FELE IN
TIMES WITH
VAPOUR ETERNE
GOD LOVETH
AND TO
LOVE WOL AND THIS
NOVGHT IN
WERNE WORLD
NO LIVES CREATURE
WITHOUTEN LOVE
IS WORTH OR
MAY ENDURE

Ann Hechle 'In Hevene and Helle'
from *Troilus and Creseide*, Book III, by
Geoffrey Chaucer, transcribed on vellum.
Page size 17·8 × 25·4 cm. 7 × 10 in.

David Howells Alphabet of
freely written flourished capitals,
lower-case and numerals, in black
and green on grey paper. Size
58·4 × 47 cm. 23 × 18½ in.

Donald Jackson Page from a book of
Alphabets and Quotations on vellum,
carried out for Señor G. Rodriguez, 1972.
Size 35·6 × 30·4 cm. 14 × 12 in.

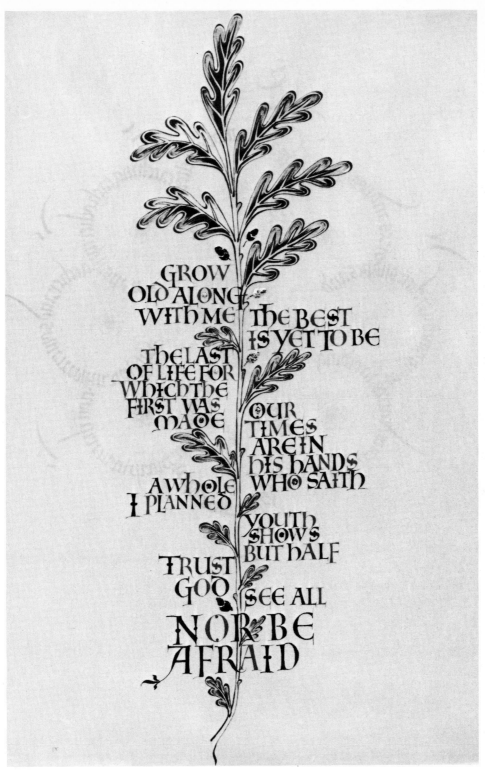

Donald Jackson Quotation from Robert Browning written in versal letters in various colours. Note the decorative arrangement of a quotation on the reverse of the leaf showing through the vellum. From a book of *Alphabets and Quotations* carried out for Señor G. Rodriguez

happy christmas, from Ieuan, Barbara and 1974 Victoria

above
Ieuan Rees Christmas card

below
Sister Leonarda Longen Quotation transcribed in a formal italic hand

A moving moment almost has to be a silent one.

from a lecture by

LEWIS MUMFORD

Picture Portfolio
Artists to the World

Picture Portfolio
The Age of Innocence

above
Sheila Waters Headings designed for the 'Portfolio' sections of *200 Years, a Bicentennial Illustrated History of the United States* published by U.S. News and World Report, Washington D.C., 1973

below
Lanore Cady Logotype for use on diplomas and stationery of the California State University, Humbolt, 1972

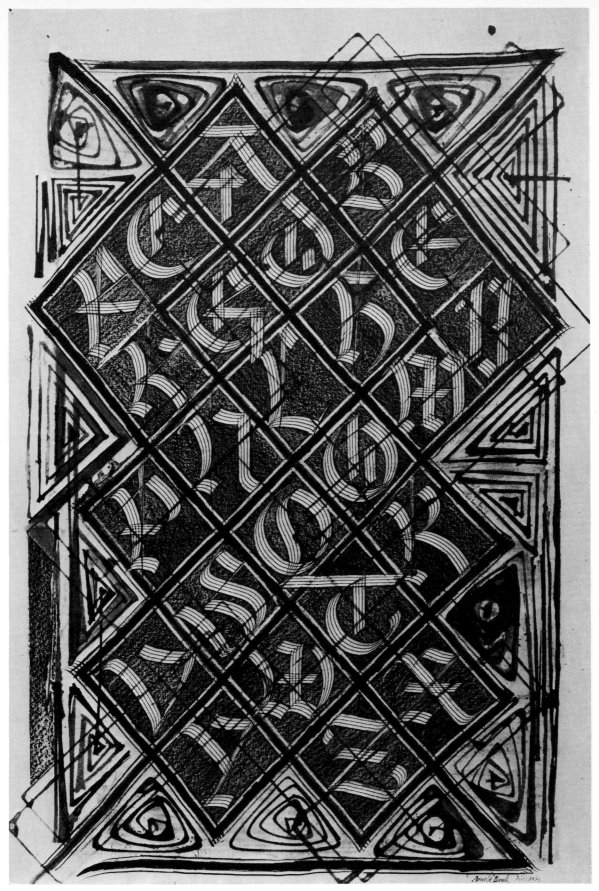

Arnold Bank Lively texture and patterning, with letters written with a music pen

Calligrafie

inbidnr

Edward M. Catich Directly written
with a brush for a lecture demonstration,
these unretouched letters clearly show the
dynamics of the signwriter's brush

YOU·ARE
INVITED·TO·AN
EXHIBITION
OF·WORK·BY
JOHN·LAWRENCE
WOOD·ENGRAVER·ILLUSTRATOR
AND
DONALD·JACKSON
CALLIGRAPHER·ILLUMINATOR
FROM
FRIDAY·MAY·24
TO·SATURDAY
JUNE·8
AT·CRAFTWORK
38·CASTLE·ST·
GUILDFORD

WE·HOPE
YOU·WILL
COME·TO
THE·
PRIVATE
VEIW·
6·PM
THURSDAY
MAY·23
WINE
AND·
CHEESE

Donald Jackson and John Lawrence Invitation to an exhibition, 1974

Select Bibliography

Anderson, Donald M.
>*The Art of Written Forms: The Theory and Practice of Calligraphy*, Holt, Rinehart and Winston, New York 1967

Benson, John Howard
>*The First Writing Book: Arrighi's* La Operina, Oxford University Press 1955

Benson, John Howard and Carey, A. C.
>*The Elements of Lettering*, McGraw-Hill Book Co., New York 1940

Bishop, T. A. M.
>*English Caroline Minuscule*, Oxford University Press 1971

Brinkley, J. (ed.)
>*Lettering Today*, Studio Vista, London 1964

Camp, Ann
>*Pen Lettering*, Revised edn Dryad Press, Leicester, U.K. 1964

Catich, Edward M.
>*The Origin of the Serif: Brush Writing and Roman Letters*, Catfish Press, St Ambrose College, Davenport, Iowa 1968
>*Reed, Pen and Brush Alphabets for Writing and Lettering: Portfolio of 27 Alphabets with descriptive book*, Catfish Press, St Ambrose College, Davenport, Iowa 1968

Dreyfus, John
>*The Work of Jan van Krimpen*, Sylvan Press, London 1952

Fairbank, Alfred
>*A Book of Scripts*, Penguin, Harmondsworth, Middlesex 1949
>*A Handwriting Manual*, Revised edn Faber and Faber, London 1975

Fairbank, Alfred and Wolpe, Berthold
>*Renaissance Handwriting*, Faber and Faber, London 1960

Gourdie, Tom
>*Italic Handwriting*, Studio Vista, London 1963; Pentalic, New York 1974

Gray, Nicolete
>*Lettering as Drawing*, Oxford University Press 1971

Haupt, George
>*Rudolf Koch der Schreiber*, Insel Verlag, Leipzig 1936

Hewitt, Graily
>*Lettering*, Seeley Service and Co., London 1930
>*Handwriting: Everyman's Craft*, Kegan Paul, Trench, Trubner and Co., London 1938

Hofer, Philip
>*John Howard Benson and his Work*, The Typophiles, New York 1957

Holme, C. C. (ed.)

Lettering of Today (Essays by Anna Simons, Percy Smith and Alfred Fairbank), Studio Books, London 1937

Holme, Rathbone and Frost, Kathleen M.

Modern Lettering and Calligraphy, Studio Books, London 1954

Johnston, Edward

Writing and Illuminating, and Lettering, John Hogg, London 1906; Pitman, London 1944

A Book of Sample Scripts, Her Majesty's Stationery Office, London 1966

Formal Penmanship and Other Papers (ed. Heather Child), Lund Humphries, London 1971

Johnston, Priscilla

Edward Johnston, Faber and Faber, London 1944

Kaech, Walter

Rhythm and Proportion in Lettering, Otto Walter, Olten, Switzerland 1956

Koch, Rudolf

Das Schreibbüchlein, 2nd edn Bärenreiter-Verlag, Kassel 1935

Lamb, C. M. (ed.)

The Calligrapher's Handbook, Faber and Faber, London 1956

Lindegren, Erik (ed.)

ABC of Lettering and Printing Types (3 vols), Museum Books, New York 1964–6

Lowe, E. A.

'Handwriting', in C. G. Crump and C. F. Jacob (ed.)

The Legacy of the Middle Ages, Oxford University Press 1951

English Uncial, Oxford University Press 1960

Macdonald, Byron J.

The Art of Lettering with the Broad Pen, Van Nostrand Reinhold, New York 1966; Pentalic, New York 1973

Miner, Dorothy E., Carlson, Victor I., and Filby, P. W (ed.)

Two Thousand Years of Calligraphy (Catalogue of the 1965 Calligraphy Exhibition in Baltimore), Walters Art Gallery, Baltimore, Maryland 1965

Morison, Stanley

'Calligraphy', in The Encyclopaedia Britannica, 14th edn

Nesbitt, Alexander

Lettering: The History and Technique, Prentice-Hall, New York 1950

Ogg, Oscar (ed.)

Three Classics of Italian Calligraphy (Facsimiles of the writing books of

Arrighi, Tagliente and Palatino), Dover Publications, New York 1953

Osley, A. S. (ed.)

 Calligraphy and Palaeography, Faber and Faber, London 1965

Reynolds, R. Lloyd

 Italic Calligraphy and Handwriting, Pentalic, New York 1969

Thompson, Sir Edward Maunde

 Introduction to Greek and Latin Palaeography, Oxford University Press 1912

Tschichold, Jan

 An Illustrated History of Writing and Lettering, Zwemmer Ltd, London 1946

Ullman, B. L.

 Ancient Writing and its Influence, Cooper Square Publishers, New York 1930; M.I.T. Press, Cambridge, Mass. 1969

Wardrop, James

 The Script of Humanism, Oxford University Press 1963

Index of Calligraphers